IMAGES
of America

SUFFERN

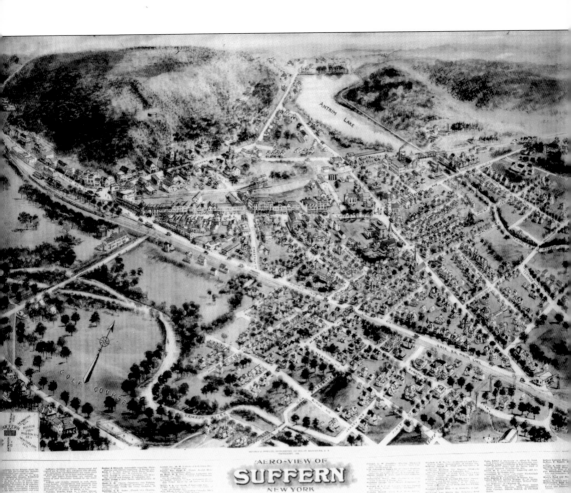

This 1922 lithograph shows a bird's-eye view of Suffern. Produced to showcase commercial and residential offerings, it captures the village's impressive setting at the gateway to upstate New York. The caption noted that Suffern "abounds in such exceptional beauty, healthfulness, and general ideal conditions." (Author's collection.)

ON THE COVER: Prominent Suffern businessmen Theodore Shuart is behind the wheel of his Hudson as he exits his service garage on Orange Avenue in the summer of 1914. At the gas pump is employee John Sherwood, and those standing around the auto are, from left to right, Ralph Fredericks, Jack Tyrell, Will Duvall, and Eddie Stevens. (Curtis W. Shuart.)

IMAGES
of America

SUFFERN

Craig H. Long

ARCADIA
PUBLISHING

Published by Arcadia Publishing
Charleston, South Carolina

Printed in the United States of America

Library of Congress Control Number: 2010922353

For all general information, please contact Arcadia Publishing:
Telephone 843-853-2070
Fax 843-853-0044
E-mail sales@arcadiapublishing.com
For customer service and orders:
Toll-Free 1-888-313-2665

Visit us on the Internet at www.arcadiapublishing.com

*For my parents, Nancy and Henry E. Long, who early in my childhood
helped to foster my appreciation for our community's local history.*

CONTENTS

ACKNOWLEDGMENTS

This book could not have come to fruition without help from many people. I want to acknowledge, with my deep gratitude, their contributions in helping me piece it all together.

As a child, I developed an interest in history. Living near village historian Gardner F. Watts and his wife, Josephine, I received a wealth of information and encouragement to fuel my passion for local history.

I am indebted to former Suffern mayor George J. Parness, who assisted me with my start as a municipal historian for the Town of Ramapo. I am also grateful to former mayor John B. Keegan and current mayor Dagan LaCorte for the opportunity to serve as Suffern's village historian.

I wish to thank the following individuals for their generous support, either historical or technical (and in some cases both) in getting this project completed: Raymond J. Sheehan Jr., Dr. Travis E. Jackson, Ruth Bolin, Curtis W. Shuart, Daniel P. McInerney, George Potanovic Jr., Dr. Bert Hansen, Hugh Goodman, Kenneth Kral, Marianne B. Leese, Rev. Edward Suffern, and Carolyn Suffern. Historians "south of the border" in New Jersey who greatly assisted me are Carol W. Greene and Joseph E. Evans. A special note of thanks to historian and photographer Robert A. Goetschius, who gave me unlimited access to his extensive collection of Suffern photographs. The Suffern Free Library and Suffern Village Museum graciously opened their impressive photographic archives, allowing reproductions for this work.

Special appreciation goes to newspaper editor and columnist Bob Baird. His instructive and generous professional advice helped in countless ways. I also wish to acknowledge and thank at Arcadia Publishing my editor Rebekah Mower and my publisher Tiffany Frary. Always available and ready to help, they provided expert guidance and assistance and were instrumental in bringing it all together.

Also, I wish to thank my wife, Robin, for her love, support, and encouragement on this and other local history endeavors. Finally, thanks to my daughters, Kristen and Stephanie, and son, Craig, for their counsel as my "assistant" historians. Unless otherwise noted, all images appear courtesy of the author.

INTRODUCTION

The long line of its ridge is soon broken into what is called the Ramapo Gap, and here, in its very jaws we stop at Suffern's.

—*Harper's New York and Erie Rail-Road Guide*, 1851

In the autumn of 1773, a young Irishman named John Suffern settled with his wife, Mary, and their three children at the foot of the Ramapo Mountains. Guarded by the lofty mountains, their new home was situated at what was known as "Point of the Mountains," a natural opening known as the Ramapo Pass.

With the start of the American Revolution, Suffern's home and tavern would host generals and other luminaries stopping along the region's two main roads, including one that ran west through the pass to Albany.

Today the Suffern area remains a busy transportation corridor, still playing host to the traveling public. Located 30 miles from New York City, the village is at the confluence of major highways—the New York State Thruway, Interstate 287, and Routes 17 and 59—all squeezing through that gap in the topography, as do the Ramapo River and the railroad. While the mountains remain, other things have changed over two centuries of history.

The region was a wilderness sparsely populated by German Palatines. Among them were other Irish, Dutch, and English pioneer families. At the close of the war, John Suffern emerged as the largest landholder. His vast property was called "New Antrim," a tribute to his Irish birthplace, County Antrim. At that time, it was not much more than a farming community. The small collection of mills and farms, connected by crude roadways and dirt paths, was slowly transformed with the arrival in the 1840s of the iron horse, the Erie Railroad. What also changed was the community's name, from New Antrim to Suffern. The railroad and the post office would indelibly link the Suffern family name to the area. Was the railroad depot named in honor of family patriarch John Suffern, or was it for his prominent son, Judge Edward Suffern, who provided the right-of-way for the rails? That question remains the subject of speculation and conjecture among local historians.

What is not in dispute is that following the Civil War, Suffern's population was slightly more than 100 people. A county newspaper, the *Rockland County Journal*, reported, "Nothing has transpired within its limits of which it can boast." But by the start of the 1870s, change was evident, as a small railroad village began to take shape. With easy commutation from New York City and the rural charm of the Ramapo Valley, Suffern quickly gained a reputation as a "pleasant summer resort," according to the *Rockland County Journal*. That ushered in the arrival of some wealthy New Yorkers who built impressive summer estates. Other families of more modest means arrived to fill the numerous hotels and boardinghouses. Some decided to stay, and homes were constructed for families of businessmen, professionals, and the working-class. Many Irish immigrants, who found employment on the railroad or in the iron works of neighboring communities, established homes in Suffern.

The area attracted such notables as David H. McConnell, founder of the California Perfume Company (Avon), and wealthy New York City financier Thomas Fortune Ryan, who, along with his wife, Ida, was responsible for some of Suffern's most venerable institutions. Others of distinction who called Suffern home were New York City lawyer Charles A. Pace and Dr. Royal S. Copeland, who was former New York City health commissioner and a U.S. senator. Dr. Paul Gibier, a student of Louis Pasteur, built a sanatorium in Suffern. Cofounder of the Boy Scouts of America Daniel C. Beard had a home in Suffern and died here in 1941. These are just some of the prominent individuals who have left their mark on the historical landscape.

Suffern's progress and population were tied directly to the growth of the business district. The shops and stores, which were clustered around the depot, began to spread along Orange and Wayne Avenues in the late 1880s and early 1890s. Suffern's main street, Lafayette Avenue, would soon be lined with stores of all types. The business district was growing and so was the population. Census figures showed Suffern had 1,250 people at its incorporation in 1896. Four years later, a bustling downtown met the needs of that population with four hotels, a lumberyard, an opera house, and about 40 retail establishments. By 1910, the population soared by 65 percent, growth unmatched until the decade of 1960–1970.

The demand for housing and the suburban way of life began to replace the farms, fields, and orchards. Early housing developments, known as the West Ward, Paradise, and Antrim Terrace, were carved out of property belonging to the Suffern, Maltbie, and Wanamaker families. With the prosperity of the Roaring Twenties, the cozy cottages of Mansfield Park and Buena Vista Heights were built on the abundant land on the outskirts of town. The opening of the New York State Thruway in 1955 would change Suffern's landscape forever.

To meet an increased housing need, subdivisions were created for the development of Foxwood, Bon Aire, Stone Gate, and Squires Gate, to name a few. In several cases, large tracts of land were annexed to have the development within the village's boundaries. But this is where my account ends. Bringing the history forward from this point would chronicle events in my lifetime, based on my youthful memory. It would also require another book.

It is important that the reader understand that this work is not a definitive history of the Village of Suffern. Rather, it is a snapshot of Suffern's rich and colorful past, as seen through the lens of the photographer. The images that follow offer a nostalgic glimpse of the streets and places of a forgotten time. Many of the homes, buildings, trees, and other scenes depicted in the photographs, paintings, and postcards have vanished or were so altered that today they are unrecognizable. As part of Arcadia's Images of America series, this photograph album of Suffern contains views that are only vaguely familiar to today's generation. Through its pages, we obtain an impression of what life was like in small-town America—Suffern, New York.

One

AT THE POINT OF
THE MOUNTAINS

Since the beginning of time, the Ramapo River flowed from its origin at Round Island Pond, located near Monroe, New York, with its journey uninterrupted, that is until the coming of man. In the level flood plain where the mountains parted and the river flowed, the native inhabitants found fertile land and a safe place to gather. It was customary to refer to an area by the natural formations. Here they met at a place they called the Point of the Mountains.

In the autumn of 1773, a young Irishman named John Suffern settled with his wife, Mary, and their three children at the foot of the Ramapo Mountains. Guarded by the lofty mountain chain, their new home was situated at the point where the mountains press down and form a natural opening, which is known as the Ramapo Pass.

John Suffern was not the first settler to be attracted by the magic of the untouched land. Nearby was a sprinkling of small colonial settlements with families who had taken up life in the rustic, wooded hills. The only major roadways, once Native American trails, were the Albany Post Road, which went west through the pass, and the road from King's Ferry (Stony Point), going south to Morristown, New Jersey. At that intersection, Suffern erected a large frame home and later added a store and tavern.

With the advent of the Revolutionary War, Suffern acted as host to many of the war's most notable and distinguished figures as they passed through or near the strategic Ramapo Pass. The grounds surrounding the Suffern homestead became a campsite for hundreds of wartime soldiers, as different Continental and French Army officers made Suffern's home their headquarters while in the area.

The following guest list of those who took advantage of Suffern's hospitality reads like a who's who of the American Revolution: Gen. George Washington, Gen. George Clinton, Lt. Col. Aaron Burr, Col. Alexander Hamilton, and many others. Several prominent foreign leaders, like French generals Marquis de Lafayette and Jean Baptiste de Rochambeau, who were involved in the war's effort, also stopped at Suffern's homestead at the Point of the Mountains.

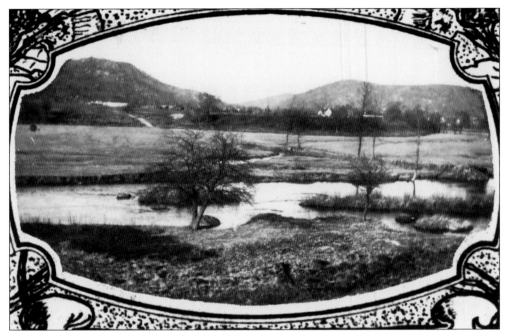

How the region got the name Point of the Mountains can be seen from this photograph that was taken more than 100 years ago. Looking west from the Ramapo River meadows, the two mountains separate, forming the gap in the Ramapo Mountains. The Dutch named these peeks Hooge Kop, or High Head, and Noorde Kop, or North Head.

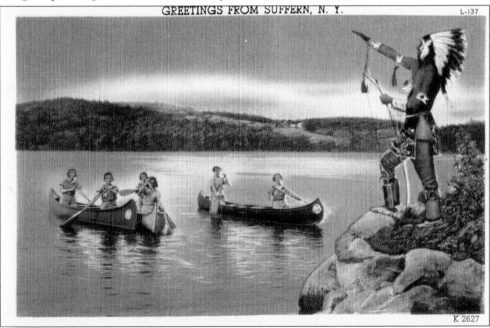

Prehistoric Suffern was intersected by well-worn paths that were blazed by the Lenape or Delaware Indians, members of subgroups such as the Minsi (Munsee) and the Ramapough Lenape Nation, who still have descendents in the community. This linen postcard from the 1930s inaccurately portrays eastern native culture.

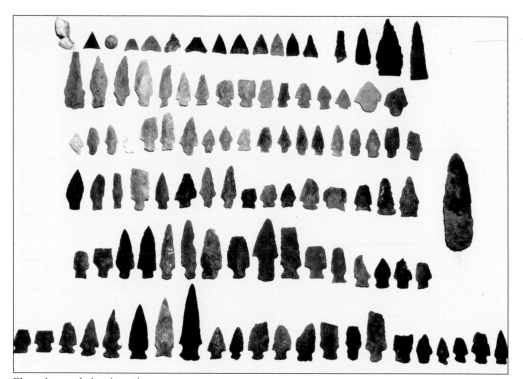

Flat, elevated, fertile soil between the Ramapo and Mahwah Rivers made Suffern an ideal spot for Native Americans, and later Europeans, to settle. Evidence of their existence is found in artifacts people have unearthed over the years. Countless arrowheads, spearheads, grooved axes, pestles, drills, and flint knives have been found in and around the village. Many of these finds have been located on each side of the riverbanks. The marshy area that today houses the Squires Gate development was reported to be a treasure trove by early souvenir hunters. Numerous rock shelters overlooking the village have also yielded magnificent finds such as an 800-year-old 10-gallon Native American vessel and the early clay cooking pot, pictured at right, found by local dentist turned amateur archeologist Dr. G. James Veith.

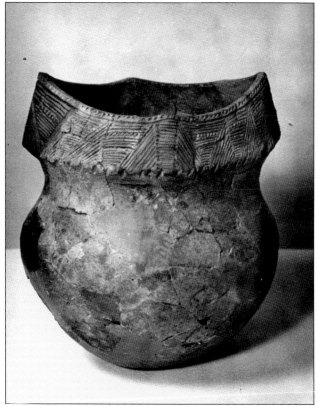

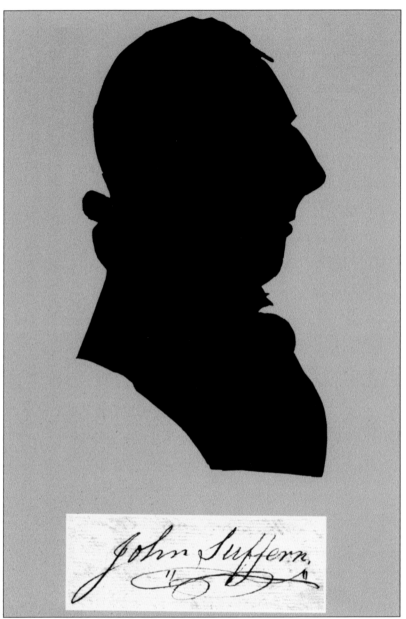

This silhouette is the only known likeness of John Suffern. Born in 1741, he emigrated from County Antrim, Ireland, in 1763, where his ancestors had been Huguenot refugees, at one time members of a prominent French family. In 1773, he settled near the Ramapo Pass in the place he called New Antrim. The home he shared with his wife, Mary, and 11 children served as a general store, tavern, and later a post office. In addition to operating a large farm, his other interests included a gristmill, sawmill, potash works, woolen mill, and an ironworks. He owned thousands of acres of land in the Ramapo Pass and extensive property in upstate Elmira. Suffern's public service record is impressive. Most notably, he was a member of the New York State Assembly (1781–1782), was appointed first judge of Rockland County in 1798, and was a state senator (1800–1803). He died in 1836, just shy of his 95th birthday, and is buried beside the Ramapo Reformed Church in Mahwah, New Jersey.

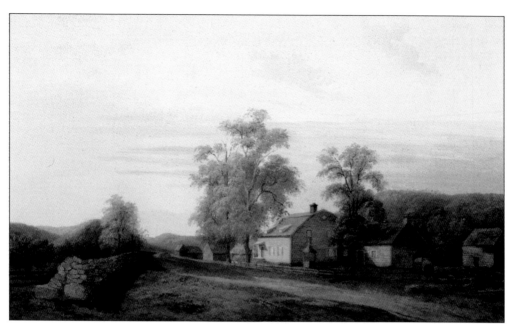

In September 1773, John Suffern built this large frame house (above) in the Dutch style. The remarkably detailed oil painting by Cornelius Ver Bryck, *c.* 1842, shows its picturesque setting against the backdrop of the mountains. The dirt road in front of the house is today's Lafayette Avenue. Located at the crossroads, Suffern added a store and tavern on the east side of the home in 1775. Its reputation attracted many luminaries of the American Revolution. The rear view of the home and tavern, sketched below by French artist Jules Arnault about 1848, depicts the smokehouse and the housing for Suffern's slaves and farm employees. The house was torn down in 1856 when a new home was built just to the east. That site today is Avon Park. (Below, Suffern/Cornell family.)

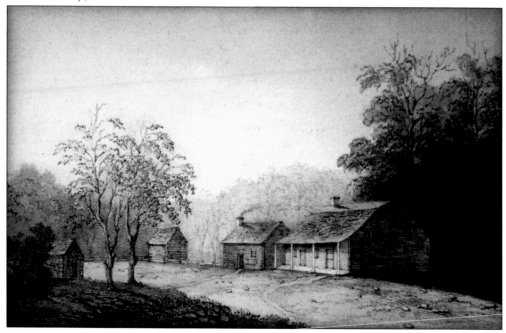

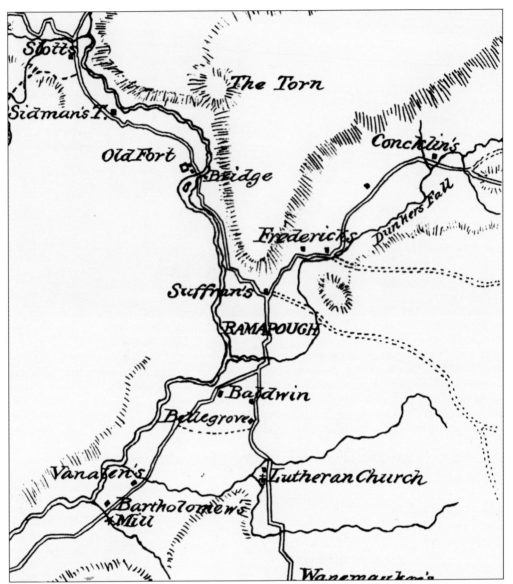

This section of a map, penned by Col. Robert Erskine in 1778, details the geographical features and important sites in the Ramapo Pass. Erskine was the geographer and surveyor of the Continental Army and produced the map at the request of Gen. George Washington. It shows Suffern's tavern (misspelled on the map, as was common in those days) prominently situated at the head of the pass and at the region's crossroads. The need to defend this natural gateway to the Hudson Highlands was evidenced by frequent visits of key military personnel and correspondence concerned with the site's fortifications. With the British in control of New York City in 1776, American military leaders recognized the need to retain control of Hudson River fortifications and the 14-mile pass through the Ramapo Mountains, the only land route between New York City and the western counties. (Suffern Village Museum.)

When France came to the aid of American colonists, French general Jean-Baptist de Rochambeau landed in Newport, Rhode Island, with an army of 5,000 officers and men. In the summer of 1781, his troops joined forces with General Washington and headed south to Virginia. After crossing the Hudson, Rochambeau's army arrived at Suffern on August 25, 1781. As they set up camp along present-day Washington Avenue, Rochambeau stayed in Suffern's tavern. After the decisive victory in Yorktown, the French Army returned to New England in 1782 and again encamped at Suffern. The beautifully executed plan of the camp site, prepared by French topographical engineer Louis-Alexandre Berthier, shows remarkable accuracy when compared to a modern-day satellite image. (Right, Princeton Department of Rare Books and Special Collections; below, Rockland County Planning Department/G.I.S.)

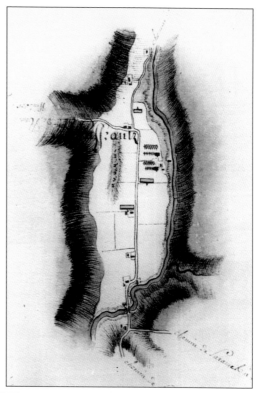

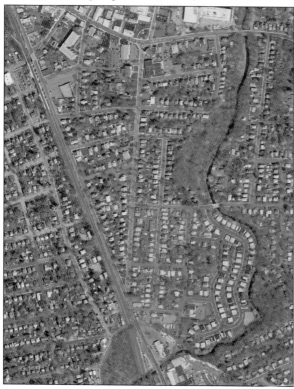

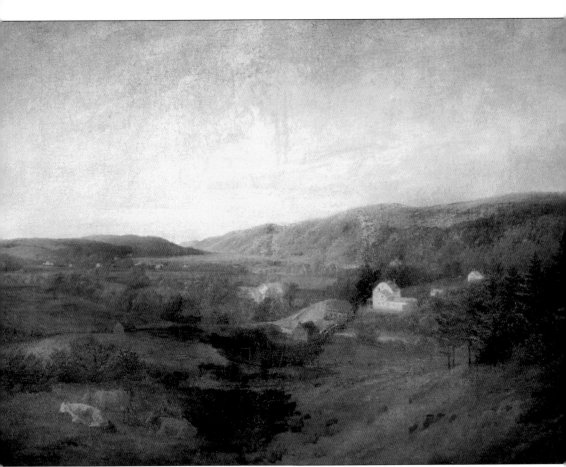

At the close of the Revolutionary War, John Suffern purchased extensive property in the Ramapo Pass. He acquired hundreds of acres, comprising much of the present western portion of the town of Ramapo. His property extended into Bergen County, New Jersey. This painting depicts Suffern's property about 1861 from a vantage point on Union Hill (which disappeared as a result of years of quarry operations), looking southwest. Called the *Six-Mile Painting*, it was done by a Frenchman who, using the alias Jules Arnault, sought refuge at the home of John's son James about 1846. Arnault served as a French tutor to the Suffern children and was an accomplished artist and violinist. Upon Arnault's death, it was discovered he was Jean Andre, Marquis de Suffren, the head of the family's French branch (different spelling) and a cousin of John Suffern. The house in the middle of the painting belonged to John Suffern's son Judge Edward A. Suffern, who is reported to have said that when he sat on his porch all the land that he saw was his, a view of 6 miles. (E. G. Suffern family.)

The post office, established at John Suffern's New Antrim on August 28, 1797, was the first official recognition of the name. Suffern was appointed postmaster, and mail service was run out of his store. In 1808, his post office was discontinued and replaced with one at the Ramapo Works because of the importance of that factory. A post office eventually returned in 1858. This time it was called Suffern.

NEW-YORK & ERIE RAIL-ROAD COMPANY.

SHARES, ONE HUNDRED DOLLARS EACH.

No. *977*

This is to Certify, That *Elizabeth Suffern* is entitled to *Ten* Shares of the Capital Stock of the NEW-YORK AND ERIE RAIL-ROAD COMPANY, subject nevertheless to the further payment of *Eighty five* Dollars on each Share thereof, at such times and in such instalments as may be required by the Board of Directors of said Company, and subject also to the terms and conditions of the Subscription to the said Capital Stock, and transferable only on the Books of the Company by *Elizabeth Suffern* or *her* Attorney, on payment of such Instalments as may be due, and the surrender of this Certificate. In Testimony whereof, the said Company have caused this Certificate to be signed by their President.

Dated New-York, *July* 183*9*

James G. King President.

T. F. Waters Secretary.

NEW-YORK & ERIE RAIL-ROAD COMPANY.
Office, No. 4, Wall Street, N. Y.

This stock certificate from the New-York and Erie Rail-Road Company for John Suffern's second wife, Elizabeth, was issued three years after construction had started. In New Antrim, the rails were laid on Suffern family property with Judge Edward Suffern, son of John Suffern, providing the right-of-way. In grateful appreciation, the Erie requested the rail station at New Antrim be named Suffern. (Suffern Village Museum.)

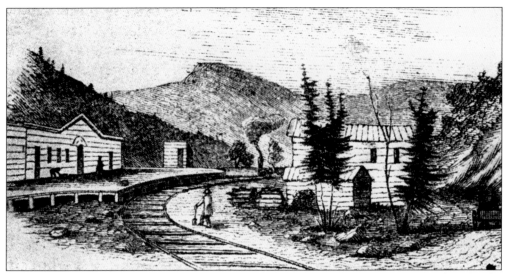

This pen-and-ink sketch represents the first train depot built in 1841 by the New York and Lake Erie Railroad at New Antrim. The modest station and platform was located at the base of the mountain along Orange Avenue, near the intersection of Wayne Avenue. *Harper's New York and Erie Rail-Road Guide* stated that a second series of tracks from Jersey City, New Jersey, connected with the original Erie line and two major railroads converged at Suffern's depot by 1848. With a steady increase in rail traffic, the area became an active hub of commercial and rail activity. By 1862, the *Rockland County Journal* newspaper reported the "Erie Railway is making some fine improvements at Suffern's . . . presenting a very neat appearance." The photograph below shows the new depot, water tower, and washhouse, which were constructed further south along Orange Avenue.

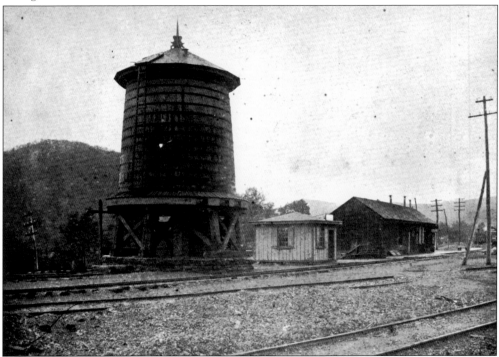

When constructed in 1888, Alanson Traphagen's building at Lafayette Avenue and Chestnut Street was the largest store in Suffern. According to *City and Country*, a meeting hall "to accommodate 600 people" was later built on the top floor. In the fall of 1891, a group met here to determine whether a village called Suffern should be created. In January 1892, a vote resulted in a 119-71 defeat for incorporation.

The *Rockland County Journal* reported that undeterred by the initial loss, "one hundred of the most important tax paying residents" met to consider resubmitting the question of incorporation to the voters. Assisting in the process in 1896 was Thomas W. Suffern, attesting to posting of 10 "incorporation notices" in public places in the proposed village of Suffern. When the polls closed April 13, 1896, the result was a resounding 206-19 for incorporation. (Suffern Village Museum.)

19

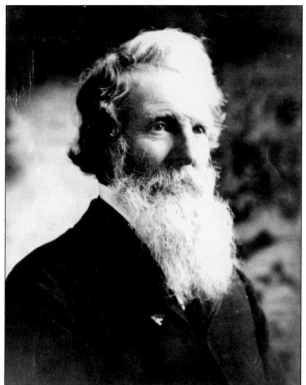

George Washington Suffern, a 77-year-old gentleman farmer and grandson of John Suffern, was called from retirement to run for president (mayor) of the new village in 1896. Having served several terms as supervisor of Ramapo, justice of the peace, and Suffern postmaster, he emerged as a strong leader for the fledgling village. He served until 1898 and died in 1903.

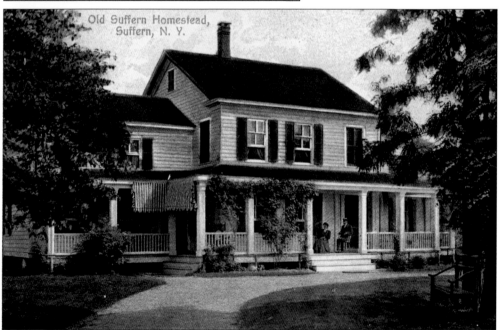

Old Suffern Homestead, Suffern, N. Y.

For the first year, village officials met in the home of Pres. George Washington Suffern. Located at Washington and Lafayette Avenues, this 1856 home had been built by the Suffern family, just to the east of John Suffern's original home. For a time, it served as the Ramapough Club and in 1920 became the parsonage for the Methodist church. It was demolished in 1968.

Two

THE BUSINESS OF DOING BUSINESS

From its beginnings as a farming community, Suffern was transformed into a major commercial crossroads with the coming of the New York and Erie Railroad in the 1840s. The completion in 1848 of the Paterson and Ramapo Railroad from Jersey City solidified that. With a small rail depot at Wayne and Orange Avenues, brothers John Cassidy Suffern and George Washington Suffern, grandsons of the family patriarch, constructed a small wood-frame building and opened a store. A hotel and other establishments soon followed in the evolution of the business district.

By the close of the Civil War, Suffern's population was slightly more than 100 people. Dwight B. Baker arrived in May 1866 and "built up the place" by constructing Suffern's first commercial row of stores and shops along Orange Avenue and also a lumber and coal yard. A small railroad village took shape around the depot. Several hotels and boardinghouses attracted more visitors each year and in the decades that followed.

Suffern's growth and commercial success was evidenced by expansion of the year-round housing and creation of a commercial hub. A thriving business district boasted 20 stores by 1889, as the population exploded to 1,100. Commercial buildings spread up Lafayette Avenue, creating a "main street." To meet the needs of a flourishing, growing, and vibrant community, Suffern incorporated as a village in 1896.

As a new century approached, the greatest and most rapid expansion in the business district gained momentum. By the early 1900s, brick buildings began to replace older wooden structures of earlier shopkeepers. In the two decades that followed, commercial construction produced significant and impressive architecture along both sides of Lafayette Avenue, Chestnut Street, and the lower portions of Wayne and Orange Avenues, creating an ensemble of large and small stores.

The footprint of the business district remains much the same today. Suffern's commercially viable and diversified downtown continues the business of doing business.

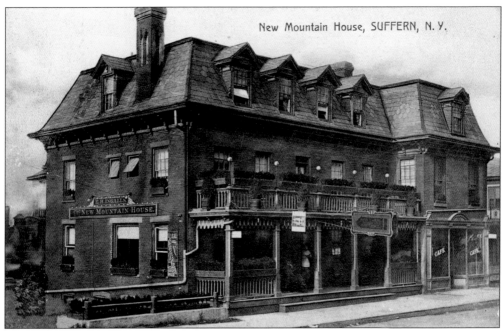

The first hotel erected to serve the rail traveler was the Mountain House. Constructed of brick about 1849 by Truxton Williams, it stood in a prime location on Orange Avenue, adjacent to the Piermont Branch of the Erie Railroad and across from the depot. By November 1938, the hotel had fallen into disrepair and was demolished for a parking lot.

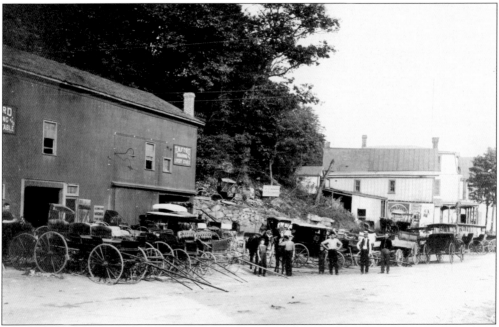

Across from the Mountain House were the livery stables of Thomas N. Ford. In this 1899 image, Ford and his stable hands are seen among his fleet of carriages, coaches, and light rigs, which, according to its advertisements, were available "for all livery purposes and kept in first class condition." It was located on the mountainside where the thruway now crosses over Orange Avenue.

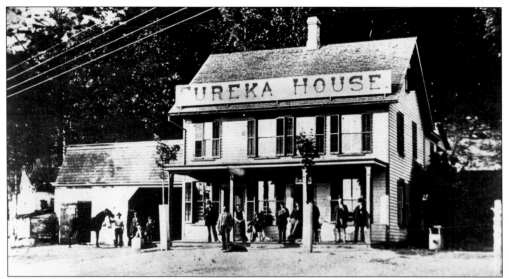

By 1869, there was a need for a second hotel for summer visitors. The Eureka House was built by Reuben Riggs on Orange Avenue, across the street from the Mountain House and depot. It quickly became a popular resort and was enlarged several times. The livery stable was converted to Rigg's Hall, the site of many community functions, including the vote to incorporate.

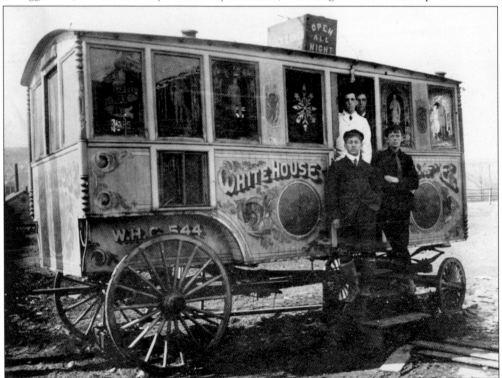

The first lunch wagon in Suffern appeared about 1905 and was parked between Orange Avenue and the Erie Railroad. Roadside cuisine was offered 24 hours a day, and this lunch wagon featured a quick lunch, including pies, coffee, milk, and cigars. When it was owned by Theodore Shuart, the business generated about $100 a month. On the steps are Spencer Jones and Harry Sinell. (Curtis W. Shuart.)

One of the earliest known images of Suffern is this 1872 view of R. L. Rathe's barbershop on Orange Avenue. The Erie tracks are in the foreground, and to the right is the dirt road leading to Haverstraw, later Wayne Avenue. The Civil War–era building later became M. E. Stall's funeral home. It was razed in 1979.

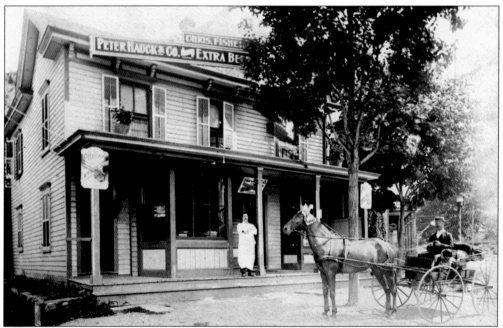

Chris Fisher stands with his arms folded on the porch of his saloon, the former Rathe Barbershop on Orange Avenue. Fisher was well-known as a manufacturer of quality cigars, having a factory in nearby Viola. According to advertisements, his 10¢ cigar, the "Robert Fulton," and his 5¢ brand, the "749," were all carefully handmade of "select tobacco with a uniform quality for the discriminating customer."

A group gathers in front of the imposing Hotel Rockland, a three-story brick building on Orange Avenue. Dwight B. Baker started construction in 1887, but the project went bankrupt midway through. The hotel was left unfinished until May 1892, when it was completed. It had an ideal location, directly across from the train depot. Once it opened, it established a good reputation as a first-class hotel and bar. It had a very large hall and 25 single rooms for rent. Overlooking Depot Park, a second-floor balcony was later added. The 1899 image below shows the bar had room for bicycle parking inside, several spittoons on the floor and bartenders at the ready. By 1939, the hotel developed serious structural issues and had to be demolished.

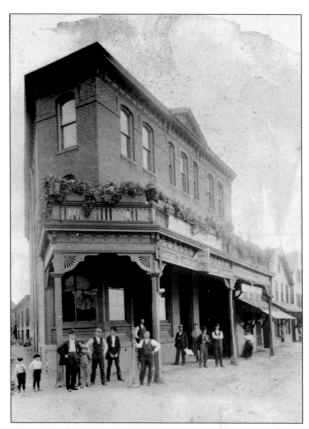

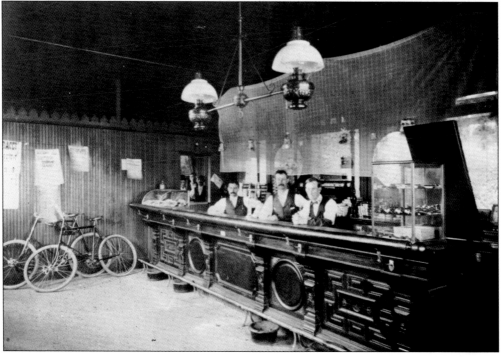

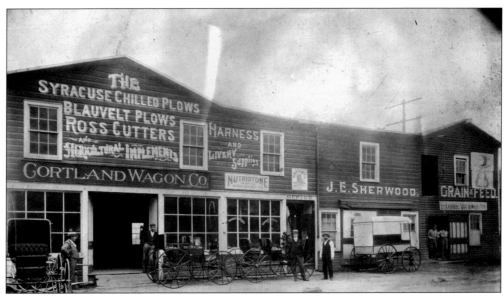

The wagon and harness shop of James E. Sherwood was between Orange Avenue and the Erie Railroad. According to the company's advertisements, it offered a "fine gentlemen's road wagon for $22.98 and sleighs starting at $15.00." Horses were extra. In this 1898 image, Sherwood is pictured on the left along with William Copeland, Francis Lynch, William F. Gurnee, C. Broadman, and a stable hand named Oliver. Town of Ramapo clerk Everett A. Cooper built the structure in 1889 and conducted both municipal and horse business from its office. In 1901, Sherwood sold the business to Gurnee and J. Blauvelt. A massive fire in March 1906 consumed the building. The loss was $13,000, with partial insurance coverage, and it was rebuilt the following year. The 1916 photograph below shows the harness and wagon establishment with an added line of products—automobile supplies. (Both, Barnes/Crisci family.)

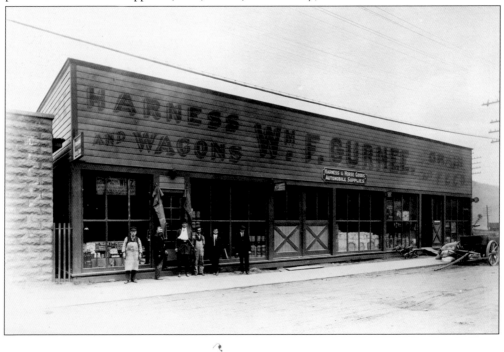

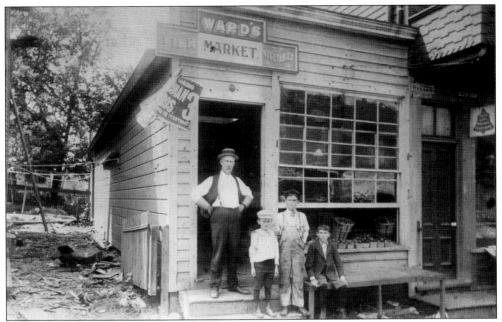

Charles Henry Ward stands in the doorway of his fish and vegetable market in 1896. Those next to him are, from left to right, his son Clifford, Richard Welch, and an unidentified child. Ward moved to Suffern in 1886 and started a grocery and dry good business with Garry Remsen. Several years later, Ward opened a cash grocery business called C. H. Ward and Son in the Washburn Block on Lafayette Avenue. (Charles H. Ward.)

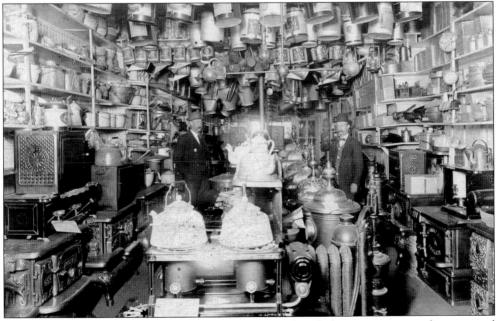

Shop owner George A. Beers (right) stands with an unidentified customer among the organized clutter in his tinsmith and plumbing shop at 39 Lafayette Avenue. He opened it in 1897 and had a wide assortment of goods, including hardware and household appliances. Beers was a charter member of the Suffern Fire Department and served as village plumbing inspector.

When pharmacist James B. Campbell arrived in 1876, he set up his drugstore in the large building on the corner of Orange and Lafayette Avenues that was owned by James H. Wanamaker. In 1889, it was the first village business to have a pay telephone. Stretched across Lafayette Avenue, the 1880 presidential election banner for Garfield and Arthur can be seen faintly. (Suffern Village Museum.)

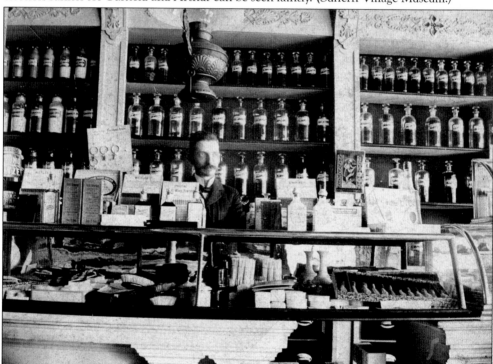

Behind the counter of his well-stocked drugstore is James B. Campbell, Suffern's first druggist, who was active in local civic affairs. In 1895, Campbell received the federal appointment as postmaster, and the post office moved to his store. In 1901, he was instrumental in starting Suffern National Bank and served as its president until his death in 1922. (Suffern Village Museum.)

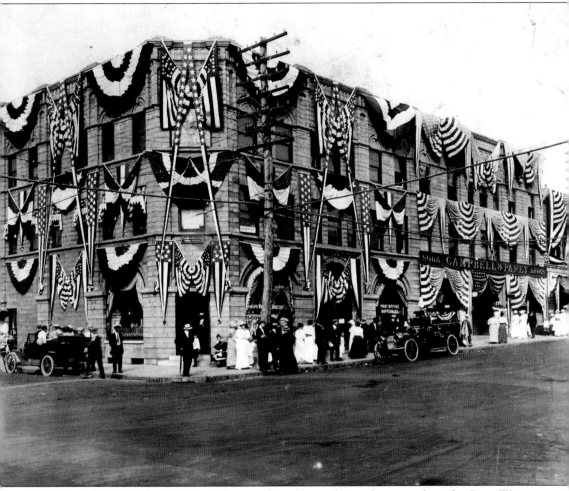

The Campbell-Van Orden Building is decorated to welcome home the troops from the Great War in this 1919 photograph. Located at Chestnut Street and Lafayette Avenue, this imposing three-story structure, made of stone and block, was the collaborative effort of druggist J. B. Campbell and funeral director Percival S. Van Orden. Constructed by local architect and contractor J. B. Schultz, the building opened in 1908. It housed a drugstore, the post office, a grocery store, offices, including those of the undertaker, and the lodge rooms for the Houvenkopf Lodge and the Knights of Pythius. In 1909, the central office for the telephone company, including a three-position switchboard, occupied the entire third floor. The Lafayette Bank and Trust opened its doors on October 20, 1928, with capital of $150,000 and a surplus of $75,000. The building was demolished during the summer of 1979, following a disastrous blaze the year before. (Suffern Village Museum.)

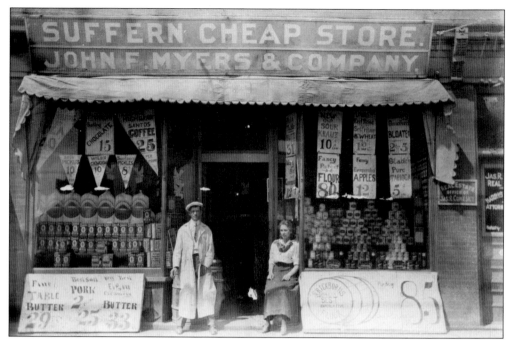

Suffern Cheap Store's name says it all about the prices, not the merchandise. Located in the Comesky Block on lower Lafayette Avenue, the brick store was part of the Rickborn and Myer grocery chain. In this early 1900s photograph, George Clinton, a clerk, stands with Elizabeth Kolleck, who is waiting for her order. (Walter Johnston.)

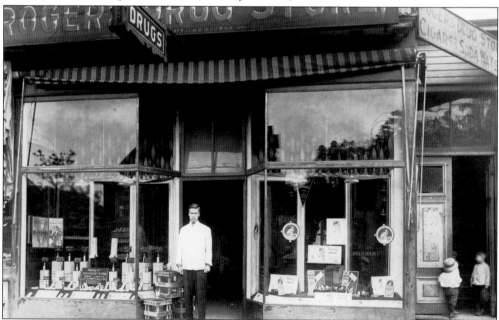

In the doorway of Roger's Drugstore, about 1915, was pharmacist Roscoe Jones. In the late 1890s, Chauncey Hemion opened the drugstore in the Traphagen Building on the corner of Lafayette Avenue and Chestnut Street. In 1917, Jones would pen the words to the World War I hit song, "America is Calling Me." (Suffern Village Museum.)

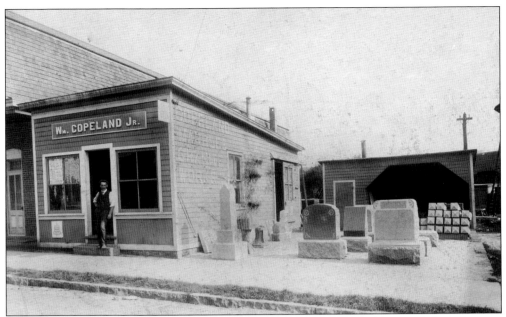

Established in 1890, the stone-cutting firm of William Copeland was highly regarded as a designer and builder of stone memorials. The accolades earned Copeland the title of "Suffern's Tomb Stone Man." In this September 1903 photograph, his son William Jr. stands outside their offices at 11 Wayne Avenue. Copeland's advice to prospective customers, "Please come visit us before your family does." (Mal Roberts Collection.)

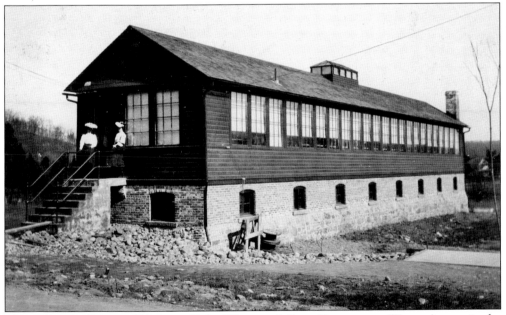

This is the new Diamond Factory of John Wenstrom's Sons Company on Wayne Avenue in the spring of 1906. The firm came from Brooklyn with machines that used commercial diamond chips to manufacture precision instruments. They also made tools, phonograph needles, surgical instruments, and electric meters. The company produced the instrument panel for aviator Charles A. Lindbergh's aircraft, the *Spirit of St. Louis*, in 1927.

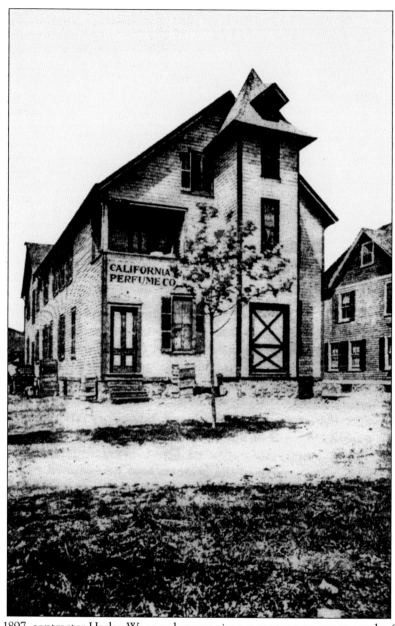

In March 1897, contractor Harley Wanamaker was given a contract to construct the California Perfume Company's laboratory at Suffern. This was 11 years after founder D. H. McConnell started selling perfume door to door. McConnell had this 3,000-square-foot facility built on Fair Street to develop and manufacture fragrances. When it opened that December, 12 people were employed. By 1902, two large additions were needed to keep pace with the demand. The original building was demolished to make room for expansion in 1939, the same year they changed the name to Avon Products. The growth of the site continued with several more additions and new buildings. The cosmetic giant's Suffern campus eventually reached 342,000 square feet and employed about 1,200 people. Still on the same site, Avon broke ground in August 2003 for a multimillion-dollar research and development center. The modern glass and steel structure replaced the older rambling conglomeration of manufacturing operations, which was demolished in the summer of 2005.

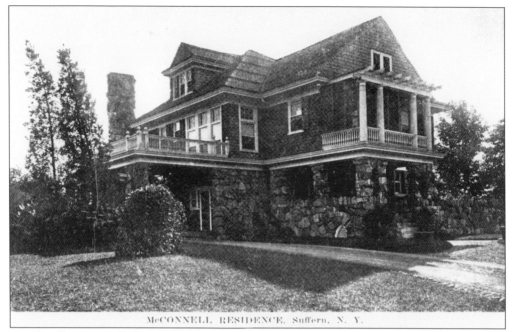

McCONNELL RESIDENCE, Suffern, N. Y.

David Hall McConnell, founder of the California Perfume Company, built a large stone-and-shingle home in 1902, which was called the Ridge. Located on a hillside at the corner of Lafayette Avenue and Oakdale Manor, the home overlooked his business and the Ramapo Mountains. McConnell died there in 1937, and two years later, the house was razed. A brick apartment complex was opened on the site in 1958.

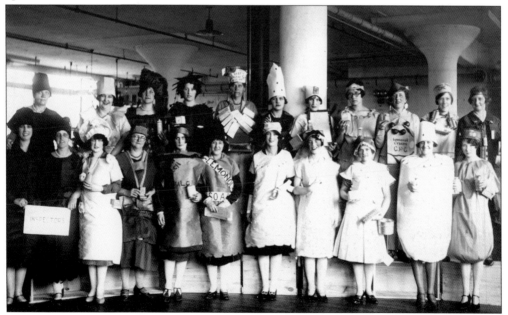

In 1927, the California Perfume Company launched a new marketing slogan, "Every Package a Perfect One." That year the ladies employed at the Suffern plant joined in the advertising campaign, dressing in costumes depicting products sold by the company. Once assembled, they posed for this photograph, entitled "The Parade of the Perfect Packages."

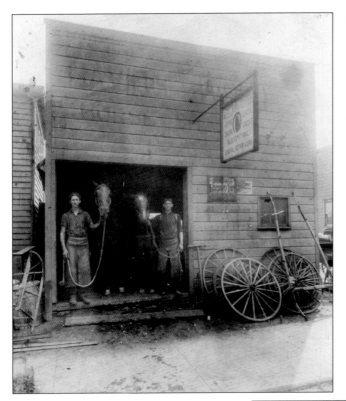

This is the exterior view of the Frank Edwards blacksmith shop. Edwards and an unidentified assistant, on the left, pose with two of their clients. Edwards gained a reputation as an experienced horseshoe replacer and advertised that all diseases of the feet were treated as a specialty. (Nelson Hadley.)

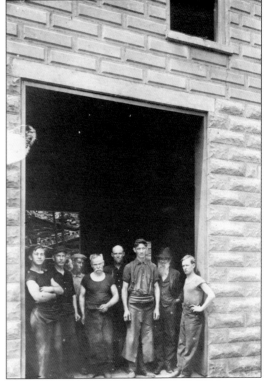

As more people switched to automobiles, Frank Edwards teamed with fellow blacksmith John H. Banker about 1916. The joint venture was located at 12 Wayne Avenue. Standing in the doorway are, from left to right, blacksmith Spencer Jones, two unidentified, Banker, unidentified, Edwards and two unidentified. According to advertisements, the men transitioned to "automobile repairing, horse shoeing, and general repairing." In 1922, Banker sold his interest to Edwards for $750.

As a photographer snapped this image in 1914, horse-and-wagon traffic stop and people gaze from the balconies of Samuel Greenstein's new brick hotel at 84 Orange Avenue. Offering a full line of first-grade bottled beer, along with a complete line of wines, liquors, and cigars, Greenstein's Hotel was a well-known establishment. After several name changes, the building is still the site of an active bar and restaurant. Greenstein was active in business affairs and the community, including the Jewish community, and sat on a number of boards of directors. He started Ramapo Valley Distributors, Inc., a wholesale distributor of beer and carbonated beverages. The photograph below, taken after Prohibition, shows the well-stocked bar. (Right, Suffern Village Museum; below, Suffern Free Library, Greco Collection.)

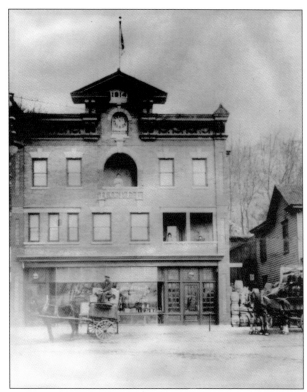

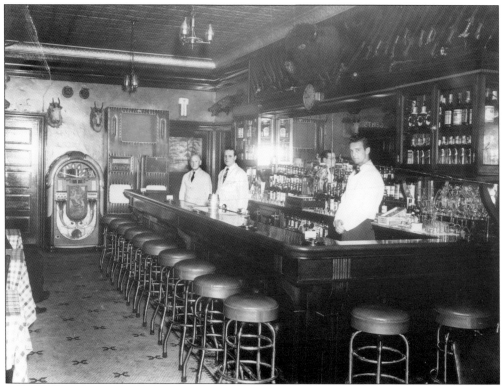

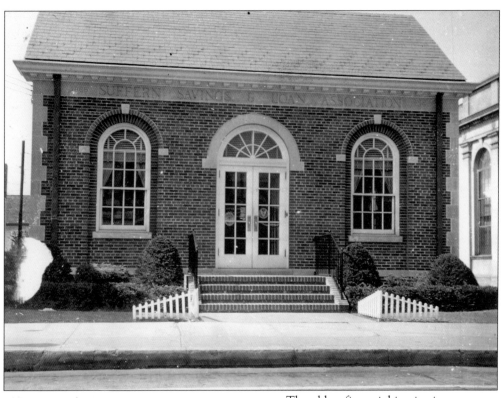

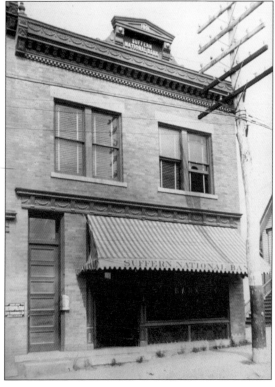

The oldest financial institution in Suffern, dating from 1886, was the Ramapo Building and Loan Association. A small group of Suffern residents put together $25,000 in capital and formed a lending group. In 1911, it became the Suffern Savings and Loan, handling mortgages and savings accounts. The association had no formal home until 1936, when this handsome brick building was constructed on Lafayette Avenue, adjacent to the Suffern National Bank.

The first bank building to be erected in Suffern was the Suffern National Bank. Ground was broken in April 1901 on Lafayette Avenue, adjacent to the St. Rose of Lima Church. The brick building was constructed by James B. Campbell, who became bank president when the board of directors organized. It opened November 1, 1901, with the first day's deposits totaling $5,656.84.

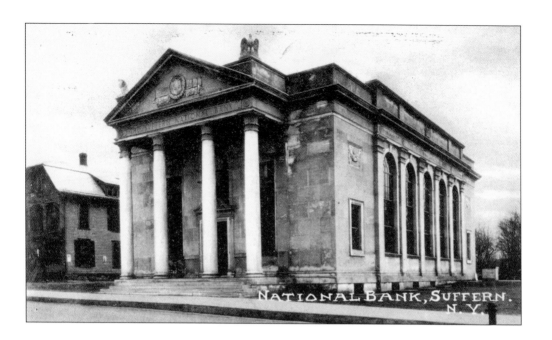

By 1919, Suffern National Bank needed to expand. The bank purchased the property at the corner of Lafayette and Park Avenues and hired a crew to take the Methodist church and remove it intact from the site. New York architect Alfred Hopkins designed an impressive four-columned neoclassical financial institution that rivaled any structure found on Suffern's main street. Originally slated to cost $100,000, the limestone and marble building, with magnificent and enhanced architectural features, pushed the price tag to upwards of $180,000. When formally opened on November 2, 1922, patrons marveled at the bank's interior, large windows, high ceiling with a huge chandelier, marble teller stations, and fancy ironwork.

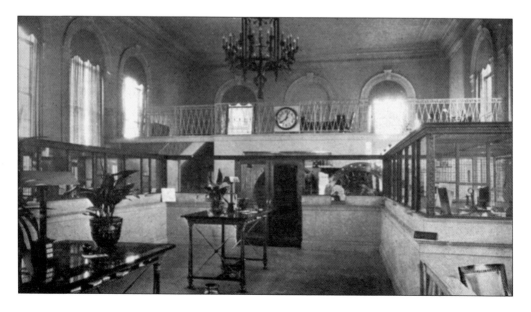

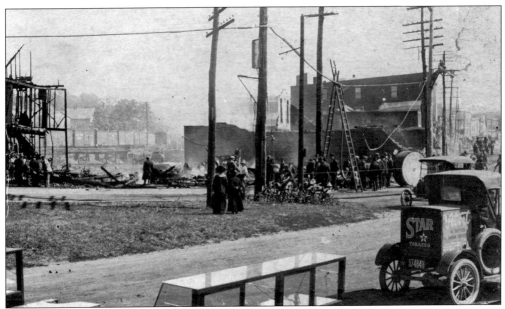

In the early morning hours of September 29, 1915, a fire started in a livery stable on Orange
Avenue. Five and a half hours later, the wind-swept blaze had leveled 14 commercial buildings,
known as the Comesky Block, at the corner of Lafayette Avenue. Ten fire companies, including
three from New Jersey, responded to aid the Suffern firemen. The loss was valued at $150,000.
The next day an estimated 5,000 people visited the ruins. A year after the fire, owner James R.
Comesky commissioned architect Henry Barrett Crosby to design a brick and concrete two-story
structure to cover the footprint of the burnt-out buildings. Constructed with an imposing clock
tower, fashionable apartments with balconies and the latest in lighting and ventilation, and large,
roomy stores, it ushered in a new age of commercial architecture for Suffern.

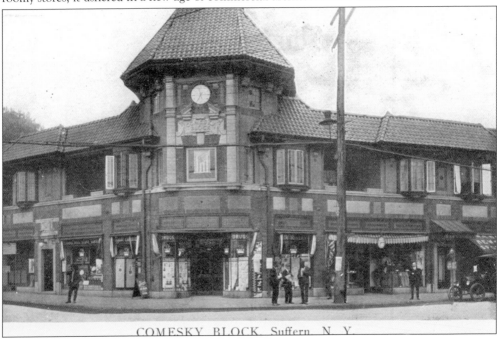

COMESKY BLOCK, Suffern, N. Y.

Trucks from the Suffern Bottling Works back up to unload beer kegs from the refrigerated railcars that were located along Washington Avenue in 1935. Gustav Mayer purchased the soda bottling business of Walter R. Conrad in 1925 and manufactured and sold carbonated beverages and near beers during Prohibition. Following the repeal of Prohibition, Mayer established Suffern Distributors, a highly successful wholesale beer distributor.

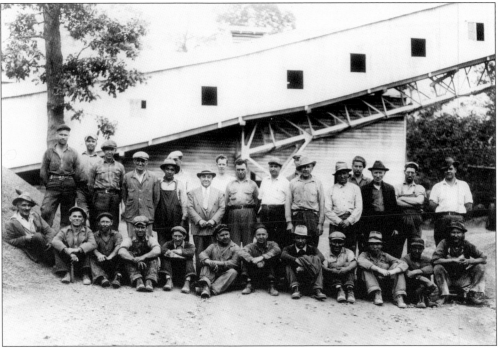

Workers for the Suffern Stone Company pose in 1938 with their boss, Joseph A. Martin (wearing the suit), in front of the conveyor for the stone crusher. The noisy, dusty operation was located on Union Hill. A referendum for the village to purchase the mountain and Lake Antrim in 1908 was soundly defeated, with the vote tallying 190-16. As a result, a trap rock quarry was established a year later. (Suffern Free Library, Greco Collection.)

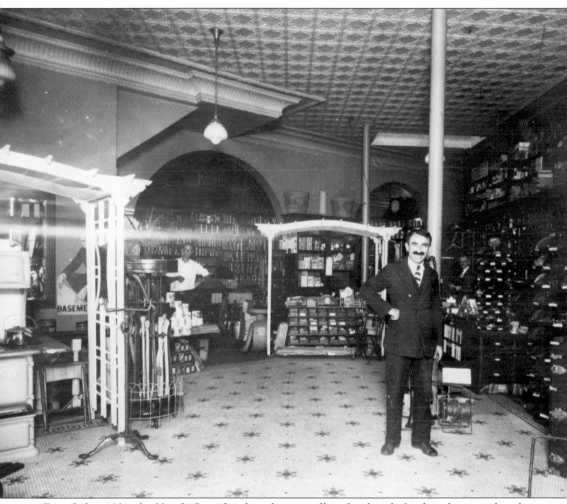

Founded in 1921, the Handy Store has long been a village landmark. In this photograph, taken about 1925, owner John A. Botta poses proudly in his hardware store. Botta was born in Italy in 1883 and emigrated to Suffern in 1911. An expert jewelry maker, Botta was involved in several business ventures before becoming the proprietor of the Handy Store. He first rented a small storefront at 98 Orange Avenue. By December 1924, he needed larger accommodations for his growing customer base. Botta leased the bigger and highly visible corner store under the clock tower of the Comesky Block. The Handy Store remained there until 1932, when the Depression forced Botta to downsize. He had to close out his houseware department and return to the original smaller store, dealing just in hardware on a cash-only basis. But within two years, Botta succeeded in moving to a larger store at 50 Lafayette Avenue. In 1957, the Handy Store moved to its present address at 92 Lafayette Avenue. (Bill and Anne Tarantino.)

The employees of Seeley Quackenbush's Tire Shop are ready to take care of business, large or small. It was advertised that the vulcanizing department could increase tire mileage and cut costs by repairing and retreading truck or car tires at a low cost. Located at 59–61 Orange Avenue, the tire shop opened in 1930. The Best Made Hat factory occupied the top floor of the building.

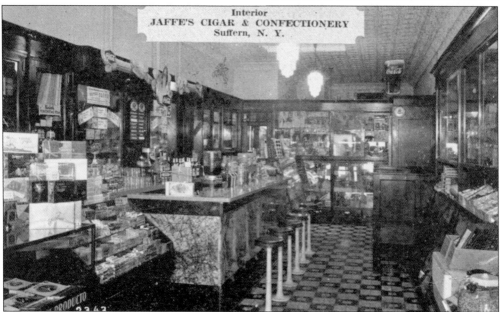

Located at 114 Lafayette Avenue, Sam Jaffe opened a confectionery and cigar store in the mid-1930s. The store offered an assortment of cigars, pipes, tobaccos, candies, and greeting cards. School supplies, toys, Kodak camera accessories, and the latest magazines filled the shelves. "Delicious sodas with Breyer's Ice Cream," read the back of this postcard, were available at the counter for 10¢. This later became the popular Brite Spot.

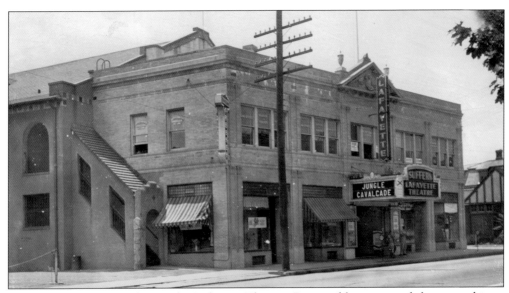

Suffern's grand movie palace is the Lafayette Theater. Designed by renowned theater architect Eugene DeRosa, the 1,000-seat movie house was built by the Suffern Amusement Company and opened on March 3, 1924, with the silent film *Saramouche*, which was accompanied by a massive pipe organ. Ticket prices were 15¢ for a matinee and 25¢ in the evening. With the theater's growing popularity, several improvements were made. In 1927, six elegant boxes were added, and balcony seating was increased. The theater was wired for "talkies" in 1929, and six offices were constructed in 1932 at the front of the building's second floor. Suffern High School graduations were held in the theater during the 1930s. Through the years, this majestic setting has continued to provide the community with countless hours of movie entertainment and more, hosting live entertainment and fund-raisers.

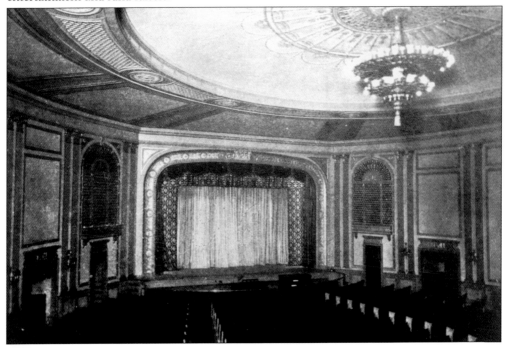

Three

THE FORTUNE OF RYAN COMES TO TOWN

Thomas Fortune Ryan and his family came to Suffern in August 1897. The village had incorporated a year earlier, which was a landmark event. The arrival of the Ryan family was of great significance; however, it was never recorded in the annals of Suffern history. In fact, very few residents, if any, were aware that anything of merit had taken place. Instead, 1897 is remembered for physical improvements in the village, such as adding street lamps and naming of roads. But things were about to change. Within the next several years, the village would benefit greatly, when Ida Ryan, who would only be a seasonal resident, displayed a special fondness for her new neighbors.

The wealthy New York City financier Thomas Fortune Ryan had purchased the former Groesbeck mansion, just beyond the village limits, to establish a summer estate, which they called Montebello. Aside from a fashionable home on Fifth Avenue in New York City, the Ryans maintained homes in Washington, D.C., and a second summer home in Lovingston, Virginia, all reflecting the wealth of one of America's most prosperous and devoutly religious Irish Catholic families.

The Ryans were as generous to philanthropies, as they were rich. It has been estimated that Ida Barry Ryan gave $20 million to various charities and endowments across the country. Most of these were affiliated with the Roman Catholic Church; however, there were sizable donations to nonsectarian institutions as well. By 1905, it was reported that Ida Ryan's benevolence covered the building of "at least one hundred new schools, churches, hospitals, and homes for the aged and infirmed."

The Montebello estate eventually comprised more than 1,000 acres. Of all their properties, Ida Ryan liked Suffern the best. She soon took a keen interest in the affairs of the village and turned her attention to the needs of her new community. It would all be done without fanfare, notoriety, or accolades. That was Ida Ryan's trademark. When the fortune of Ryan came to town, Suffern would be on the receiving end of several big gifts for a small village.

Born Ida M. Barry in Baltimore, Maryland, on December 21, 1854, she met Thomas Fortune Ryan when he came to work for her father's dry goods business. They were married in 1873 and had seven children, two of which died at a young age. Ida Ryan's notable gifts and good deeds earned her the title of "Suffern's First Lady." She died at Montebello on October 17, 1917.

Thomas Fortune Ryan was born in Lovingston, Virginia, on October 17, 1851. An orphan at age nine, he eventually would become the 10th wealthiest man in the nation. After marrying the boss's daughter, he used her dowry to launch his business career. Ryan amassed millions in urban transit, railroads, tobacco, insurance, banking, rubber, and diamonds. When he died in 1928 at age 77, his estate was worth over $200 million.

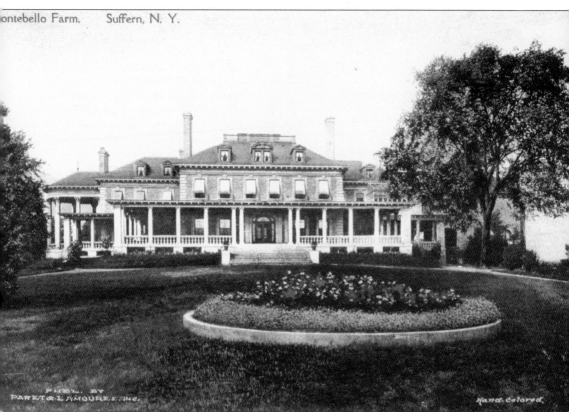

PHOT. BY
PARET & LAMOURET, INC.

Hand Colored.

This impressive brick and stone mansion was built by the Ryans in 1901. It sat on the site of the former David Groesbeck mansion, named Oldenwald, an elaborate frame Italianate-style dwelling built in 1868. Groesbeck, a stockbroker, sold his property in 1885 to Richard Muser, a lace importer, who lived there until he committed suicide on the estate in 1893. Lawyer and former state senator Eugene S. Ives was the next owner and named the home Beaupre. Financial difficulties led Ives to sell the mansion to Ryan in 1897. They named the property Montebello because of the commanding view of the Ramapo Mountains from the piazzas. Within three years, they had the elegant mansion torn down and replaced with this Georgian Colonial Revival–style building at a cost of $600,000. The house included such amenities as a two-lane bowling alley, an electric elevator, and a private chapel. It was said that from atop the mansion, Ida Ryan could view each of the substantial homes she built for her five sons in the surrounding countryside.

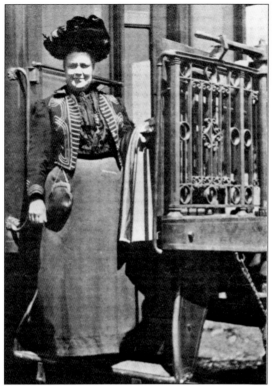

Suffern residents could mark the beginning of summer with the arrival of the Ryan's private railroad car. Parked on a separate siding on the Piermont Branch, this "mansion on wheels" meant the Ryan family was here for the season. In this rare image, Ida Ryan is stepping from her car, named the "Pere Marquette" (below). Built in 1901, the railcar cost $19,785 and was complete with an observation area, dining room, sleeping quarters, and kitchen and crew area. The most unique feature was the chapel, since very few rail cars with chapels were allowed by the Catholic Church. Ida Ryan received permission from the Vatican, as did the Queen of Spain. Thomas Ryan also had his own private railcar, the "Oak Ridge." It did not contain a worship area, but his silk and oak upgrades pushed the cost to $40,805. (Below, California State Railroad Museum.)

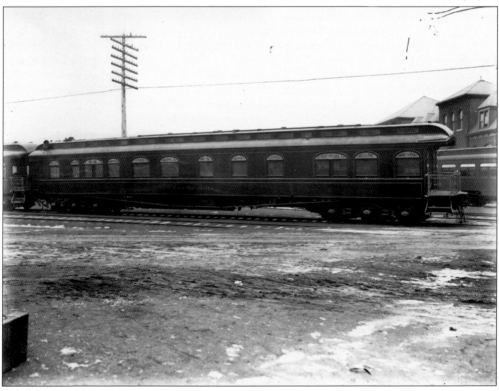

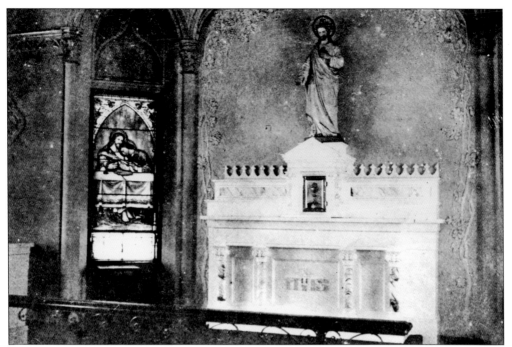

This is a view of the altar in the Ryan's private chapel at Montebello. Mass was said daily, with the priest either arriving from Sacred Heart Church or Mount Eymard Seminary. A 425-pound bell that hung outside in the western portico was rung to announce the start of services. A steel exterior staircase led to the chapel, allowing farmhands to attend without passing through the family quarters.

The stables at Montebello Farm were a massive ensemble of brick buildings. Since the estate was a working farm, the complex had carriages (later automobiles), farming equipment, horses, cattle, and a henhouse. The coachman and his family had living quarters above the stable.

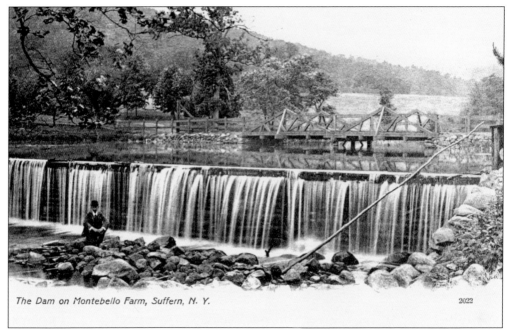

The Dam on Montebello Farm, Suffern, N. Y. 2022

The Mahwah River was dammed to create a small lake on the estate. During winter, ice was cut on the pond and taken to the mansion's icehouse. The bridge in the background carried the driveway for the rear entrance to the estate, off Haverstraw Road. That dirt road today is Mayer Drive.

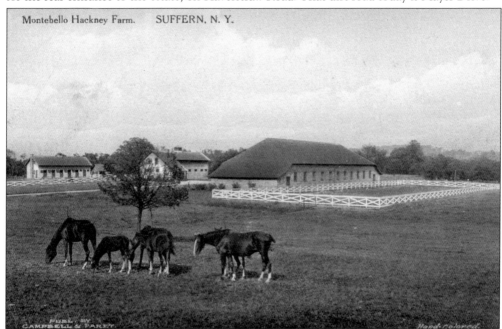

Montebello Hackney Farm. SUFFERN, N. Y.

In the fall of 1909, work began on the Montebello Hackney Stud Farm. Located on the "flats," today's Karsten Drive area, several stables were built and a generous paddock was enclosed with a white fence. The large building housed an indoor exercise ring, manager's office, and a blacksmith shop. *City and Country* newspaper predicted that "Montebello should be famous for its harness horses in a few years."

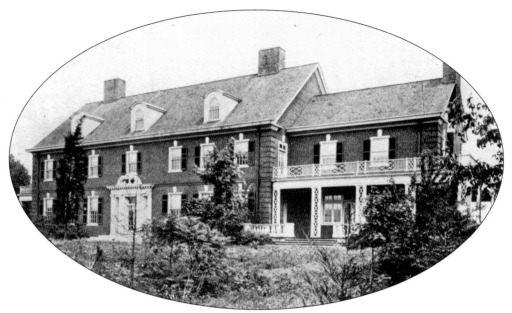

Barry Moore was the country home of John Barry Ryan, the Ryans' eldest child. A long serpentine driveway that is off Montebello Road leads to the imposing Georgian Colonial brick home, which stood on 70 acres. This mansion was built between 1907 and 1908. The New York Archdiocese owns the building and property today.

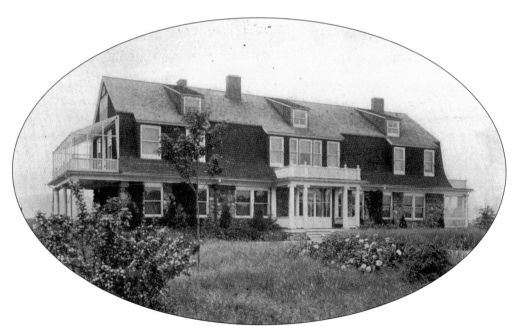

This is the second country home of Allan A. Ryan. His first estate, Strawberry Patch, was built on Mile Road in 1907. It is unclear why he relocated to a 56-acre site off Lafayette Avenue and erected this stone and shingle home in 1912. His new residence sat on a hill overlooking the property of the School of the Holy Child, which his mother had purchased in that same year.

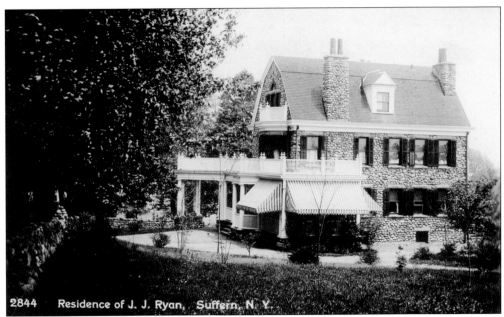

Originally, this handsome cobblestone house was constructed in 1898 as the winter house for the Ryan family. The building cost $15,000 and was designed by New York City architect C. Ritterbush. While the new Montebello mansion was being built between 1901 and 1902, it served as their temporary summer home. It also served as a guest cottage until their youngest son, Joseph, was old enough to have his own estate.

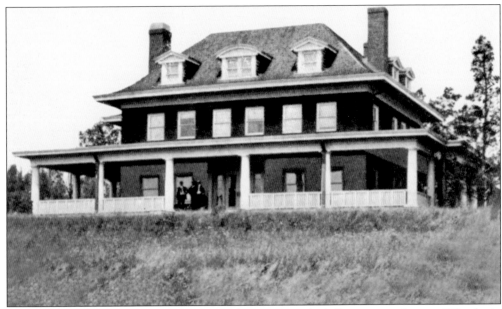

A wide, sweeping veranda provided a spectacular view from the hilltop country home of Clendenin J. Ryan. Built in between 1907 and 1908, Butternut Farm was located on Mile Road. The 37-acre estate contained several large stables and barns. The large brick mansion was demolished in May 1974.

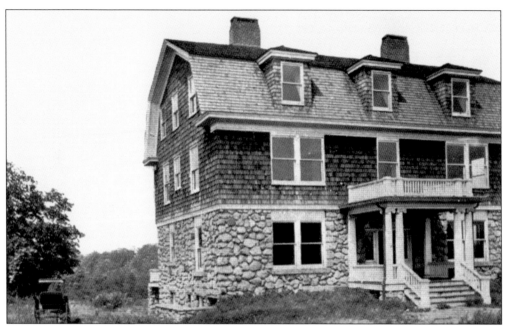

This large, modest stone and shingle home was called Hilltop. It was built for Ida Ryan's daughter-in-law Lillie Bondurant Ryan in 1907, following her husband's (William Keane Ryan) untimely death in October 1906. The house sat on 36 acres on Hemion Road. Unlike other members of the family, Lillie Ryan spent little time in Suffern. After serving as an apartment house, it was razed in 1997.

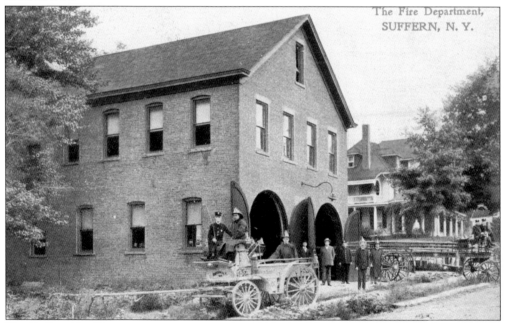

The Suffern Fire Department was organized in 1900 after Ida Ryan offered to buy fire apparatus if the village would build a place to house it. In 1901, Suffern erected a brick firehouse on Wayne Avenue at a cost of $2,000. Ryan provided two hose carts, plenty of hose, and couplings. She also provided books, games, and a piano for the firemen's off-duty entertainment.

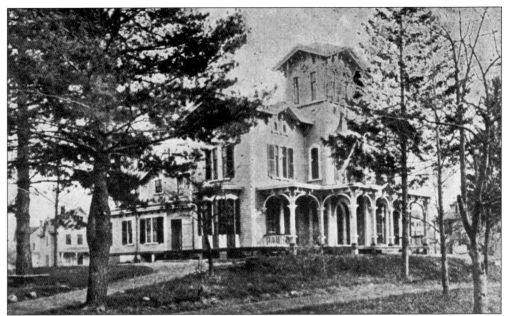

In July 1902, Ida Ryan established Rockland's second hospital when she purchased the former Suffern-Maltbie-Messimer mansion on Orange Avenue and East Park Place. She gave it to the Sisters of Charity, who opened the doors as Good Samaritan Hospital on November 12, 1902. The seven-bed "emergency hospital" was staffed by seven nurses and six area doctors.

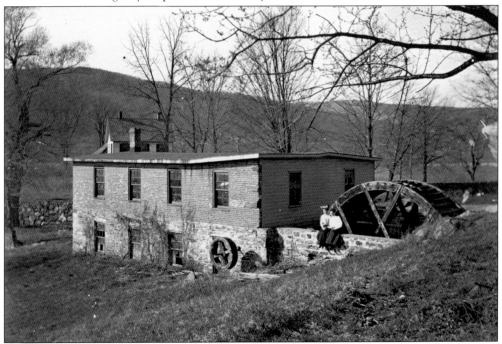

Two women pose by the mill wheel of the old Jacob Wanamaker Farm on Montebello Road. In July 1905, Ida Ryan added to her gift to Good Samaritan Hospital when she gave this 40-acre estate to the Sisters of Charity. She also gave the sisters a 19-acre, fully equipped farm, so they could provide the staff and patients with fresh fruit and vegetables.

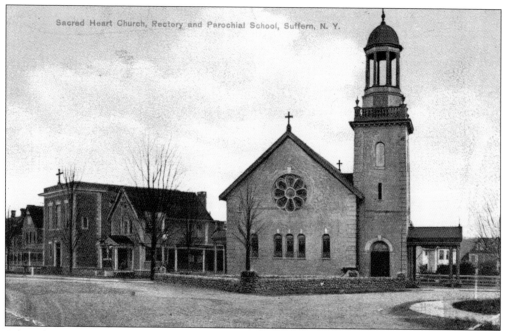

After Ida Ryan's gift of Sacred Heart Church was dedicated in 1903, she and her husband provided the funds in 1905 for a rectory to be constructed on Lafayette Avenue, located next to the church. Five years later, she contributed to the building of a new parochial school that would be adjacent to the rectory. It opened November 25, 1910, with 70 pupils.

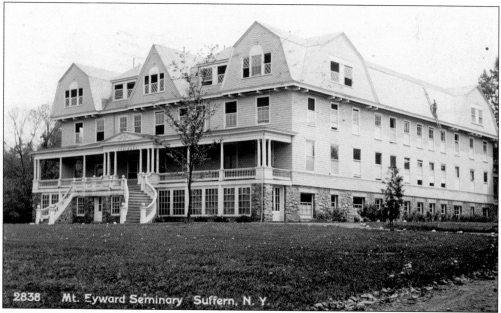

2838 Mt. Eyward Seminary Suffern, N. Y.

Following the death of Dr. Paul Gibier, his former sanatorium on Lafayette Avenue was turned briefly into a youth military academy and then a boardinghouse that was known as Tuxedo Hall. In 1904, Ida Ryan paid $16,250 for the property and gave it to the Fathers of the Blessed Sacrament for Mount Eymard Seminary. It opened with 15 "bright little boys" who were under the charge of Father Pilon.

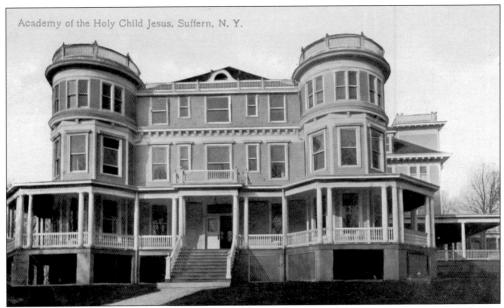

When the estate of Ferral C. Dininny Jr., known as the "Match King," came on the market, it was purchased by Ida Ryan for $250,000 in 1912. The 53-room mansion and 43 acres were given to the Sisters of the Holy Child, who opened a private boarding school for girls. The building was sold to the Salvation Army in 1972 and demolished in 1989.

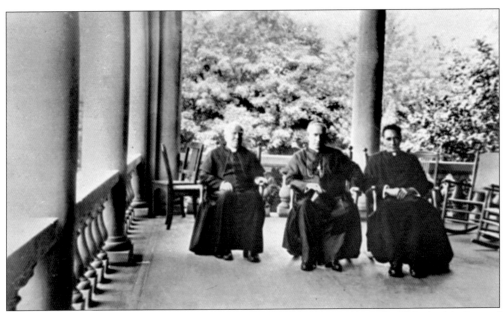

Following Ida Ryan's death in 1917, the Montebello estate was not easily sold. Archbishop of New York, Patrick Cardinal Hayes, purchased the mansion and 180 acres in June 1921 for use as a summer villa by students at the St. Joseph Seminary and College in Yonkers. Hayes, pictured center, is seated on the mansion's front porch in 1926. It was sold to Gustav Mayer in 1944.

Four

ALL ROADS
LEAD TO SUFFERN

In 1921, the Suffern Board of Trade produced a booklet entitled, *All Roads Lead to Suffern*. The publication was filled with advertisements and informative articles extolling the virtues of Suffern as an "ideal" community to buy a home, start a business, shop in the downtown, or vacation in the beautiful Ramapo Valley. The reason to celebrate and "sell Suffern" was the recently completed concrete state highway known as Lafayette Avenue, Suffern's main street. "Shell holes" had made the road practically impassable, forcing a detour and cutting tourists off from some of the "state's most historic territory." But the village really did not need an advertising brochure to proclaim that all roads lead to Suffern. Nature and man accomplished that years before.

At the mouth of the Ramapo Pass, Suffern was the starting point, or hub, for roads leading to and from important directions. The native inhabitants had their crooked paths or trails worn into the soil by foot or horse traffic. As the European settlers arrived, they too followed in these footsteps and blazed other trails, creating crude roads, studded with rocks, stumps, deep ruts, and mud holes. Travel in that time was by necessity, not pleasure. A need to create dependable routes between important sections of the county and the state led to the building of the Orange Turnpike and the Nyack Turnpike. Both highways would lead to Suffern, and later so did the railroad.

By the close of the Civil War, the *Rockland County Journal* newspaper reported that "Suffern being at the fork of four wagon roads, the Erie Railway passing through it . . . gives the inhabitants good facilities for travel in any direction." Travel became more common and easier. As the automobile began to displace the horse and carriage from roadways, Suffern was poised at the gateway. Improvements in roads helped the motoring public navigate the region. The completion of Lafayette Avenue in 1921 became the "connecting link in the chain of good roads leading to and through Suffern to all of New York State," thereby having all roads lead to Suffern.

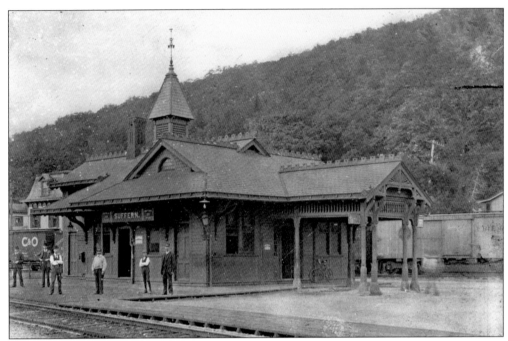

At the junction of two rail lines, Suffern's station was an important stop on the Erie Main Line. A larger, more impressive Victorian depot was erected in 1887. When it opened, the *Rockland County Journal* newspaper remarked, "The building is an ornament to the village." In this 1902 image, the station agent stands on the platform with other rail employees and passengers awaiting the next train.

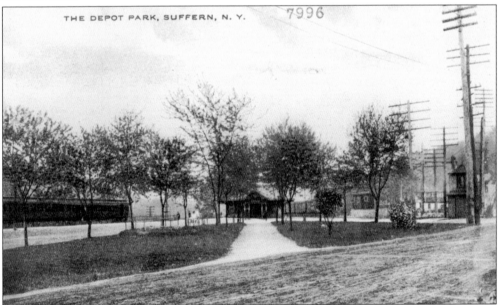

Depot Park was created along Orange Avenue to enhance the appearance of the railroad station area. The pedestrian and carriage plaza was complete with grass, crushed stone pathways, trees, and a fountain. As the automobile began to replace the horse and wagon, the area eventually became a parking lot. Today it is the municipal "A" lot.

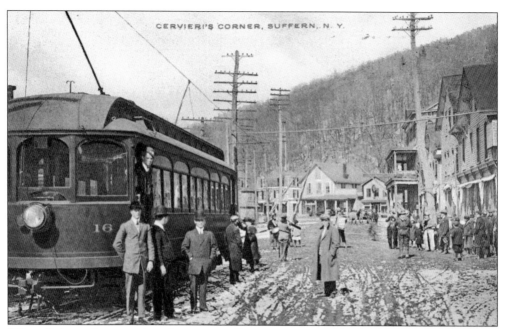

When first put into service, the green trolley car was a popular and convenient means of transportation to the big city department store in Paterson, New Jersey. The 15-mile trip took less than a half-hour, and a round-trip cost 30¢. Groups could charter a special trolley for an all-day outing for $12.

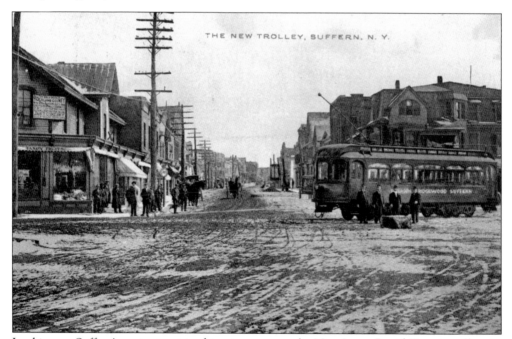

Looking up Suffern's main street in this winter scene, the New Jersey Rapid Transit trolley sits at its northern terminus, a granite horse trough. In June 1911, the trolley line began operation from Suffern to east Paterson, New Jersey. The tracks ran along Orange Avenue, parallel to the Erie Railroad.

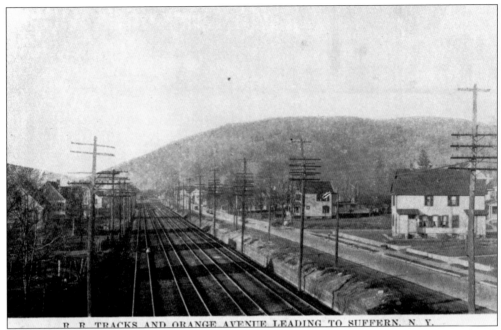

R. R. TRACKS AND ORANGE AVENUE LEADING TO SUFFERN, N. Y.

In 1848, a single track carried the Erie Railroad from Jersey City to Suffern, where it joined with the Piermont Branch. This soon became the railroad's main line, and additional tracks were added as seen in the early-1900s postcard. Four tracks physically separated Suffern from the residential area, which was known as the West Ward. Crossing the busy tracks at any one of three unprotected grade crossings could be dangerous. Alarmed by a growing number of both pedestrian and horse-drawn carriage fatalities, village and railroad officials agreed on a plan. The postcard below shows the massive overhead steel pedestrian bridge that was erected to span the tracks at Maltbie Avenue. Two underground tunnels were also dug, one at Chestnut Street and another south, at the New Jersey state line, which also eliminated the hazardous grade crossings.

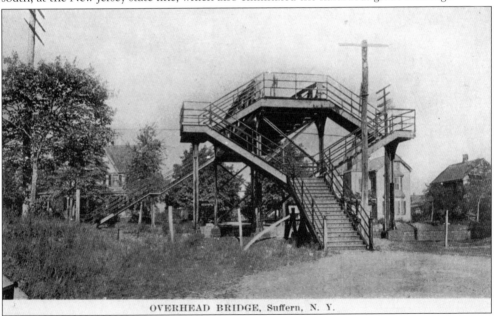

OVERHEAD BRIDGE, Suffern, N. Y.

With boxcars sitting on the rails adjacent to the Erie Freight House, the workers stop to strike a pose amid the cargo they just unloaded. In 1887, the wooden freight house and loading dock was constructed next to the grade crossing at Orange Avenue. The building was used for freight until 1963. Following years of neglect, it was demolished by the railroad in 1984.

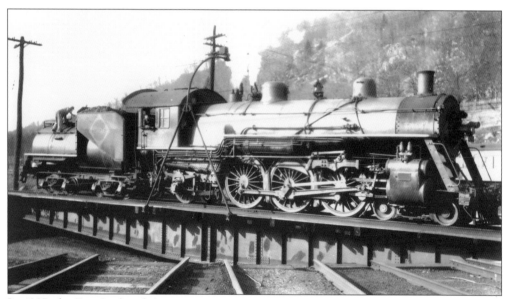

In 1887, the Erie Railroad Company removed an engine house and turntable from what had become the center of the business district. A five-stall frame engine house and a 90-foot diameter turntable were erected at the new site near Hillburn. There are no images that show the engine house or other structures that have been located there. This is an Erie 4-6-2, No. 2550, on the turntable May 1, 1937.

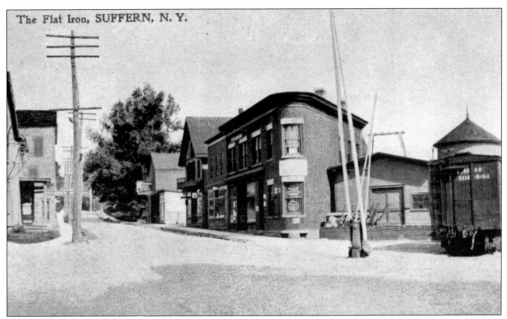

The Flat Iron, SUFFERN, N. Y.

At the intersection of Wayne and Orange Avenues was Millard A. Hallett's Flat Iron Building. Constructed of brick in 1900, it was so named for its triangular shape that resembled a flat iron. Painted on the postcard, the small freight house, water tower, and crossing gate are adjacent to the Piermont Branch tracks of the Erie Railroad.

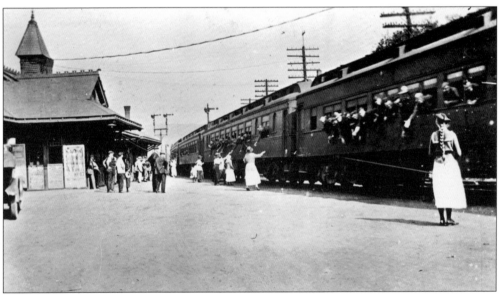

World War I troop trains arrive at Suffern depot in spring of 1918, carrying infantrymen on their way to battlefields in Europe. As the train stops at the water tower for the steam locomotive, Suffern residents greet the soldiers and offer candy and cigarettes. In return, many of them hand letters to be mailed home to their loved ones.

This is a rare image of R. F. Galloway's "Wash House" on Orange Avenue. It was the first meeting place for a small group of Suffern men who, in 1866, joined together to form the Ramapo Masonic Lodge 589. The 14 members met here until their growing membership forced them to relocate across the street to fellow Mason C. B. Haring's building. (Ramapo Lodge 589 F&AM.)

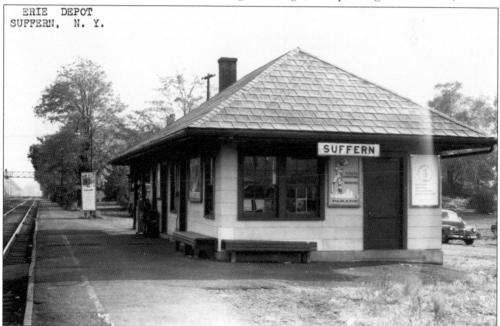

On New Year's Day 1941, a new Erie station opened in the West Ward at the intersection of Chestnut and Ramapo Avenues. A series of fatal accidents near the old depot led village officials to push the Erie Railroad Company to build a new station with passenger access to both sides of the tracks. Previously, passengers had to walk across the tracks.

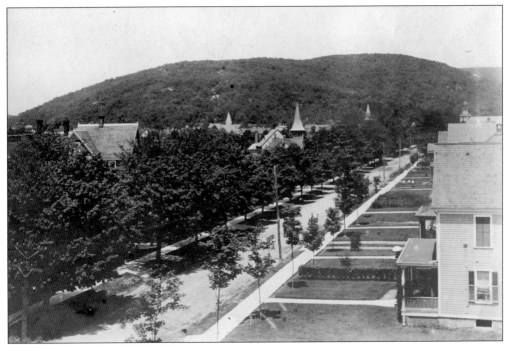

Looking north from the rooftop of a home on Washington Avenue, there is no evidence that a little more than 100 years earlier, approximately 5,000 French troops camped along what was then called Suffern's Lane on their way to Yorktown. Steeples of the Presbyterian, Methodist, and Episcopal churches and the dome of the Catholic church poke through the top of the trees.

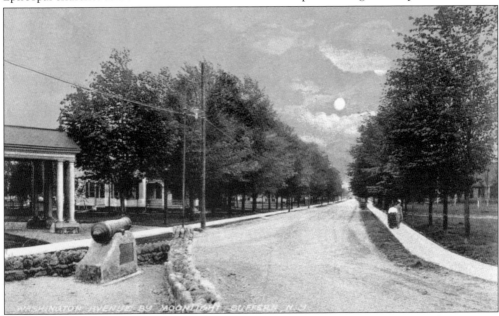

For many years, the ground at the intersection of Washington and Lafayette Avenues, the "Historic Crossroads of the American Revolution," was just a grassy triangle. In 1908, Charles E. Suffern, grandson of John Suffern, donated a cannon to the village. The Village Board decided to mount the gun on a granite base, facing south, with a stonewall protecting it.

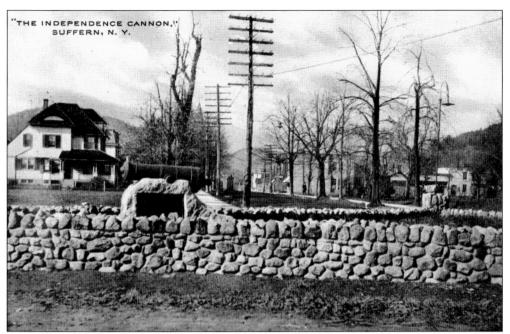

"THE INDEPENDENCE CANNON," SUFFERN, N. Y.

Village board minutes show that the $60 contract for the stone and mason work for the triangle was to be awarded to the "Italians residing on Chestnut Street." Not all Suffern residents were pleased with the new stone triangle, which was nicknamed "Porter's Fort" after Henry A. Porter, the mayor in office when it was built. A 1909 vote to have it removed was defeated, 102-52.

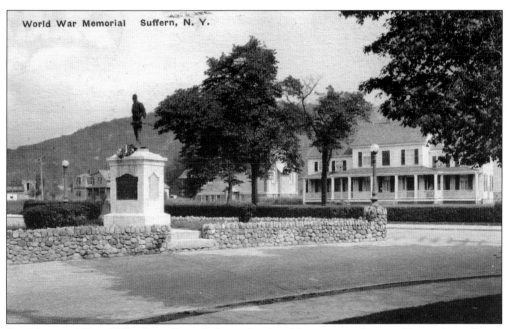

World War Memorial Suffern, N. Y.

On Memorial Day 1921, the village dedicated a doughboy statue, designed by sculptor Pietro Montana, and placed it on a pedestal inside the triangle. The names of men and women who served in the Great War were placed on a bronze tablet on the monument. It was never envisioned that future generations would need to be listed, but sadly, other plaques have been added.

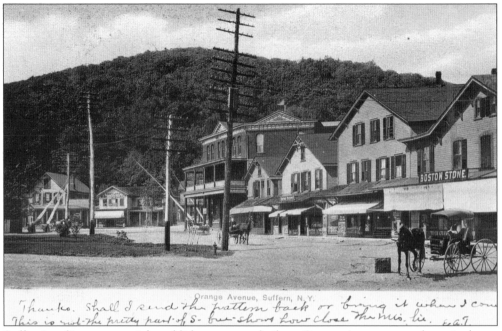

Orange Avenue, Suffern, N. Y.

Thanks. Shall I send the pattern back or bring it when I com This is not the pretty part of S- but shows how close the mts. lie. E.a.T.

Suffern's earliest commercial establishments were built on Orange Avenue, near the train depot. The frame buildings on the right were built by Dwight Baker in the 1860s. The large brick building with porches is the Hotel Rockland; beyond are the railroad crossing gates. A horse and carriage stops at the granite watering trough. Depot Park is to the left.

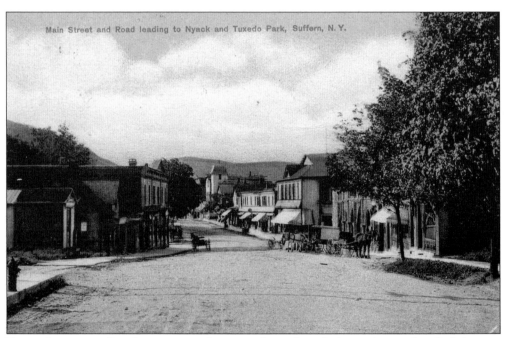

Main Street and Road leading to Nyack and Tuxedo Park, Suffern, N. Y.

Known for its unusually wide main street, this postcard view shows Lafayette Avenue from Park Avenue, looking west. Businesses along the thoroughfare enjoyed well maintained dirt roadways and spacious accommodations for hitching horses and wagons to granite posts outside their establishments.

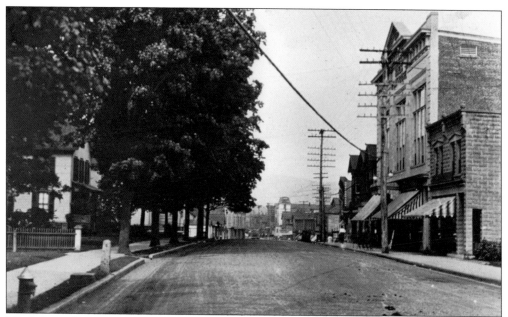

Until the early 1900s, the upper end of Lafayette Avenue was mostly residential. Most commercial buildings were modest two-story structures until 1914, when Daniel Hines built his massive $60,000 brick playhouse. That October, former president Theodore Roosevelt spoke to an overflow crowd at a Progressive Party meeting in the huge hall. The playhouse later hosted vaudeville acts, movies, roller-skating, and bowling.

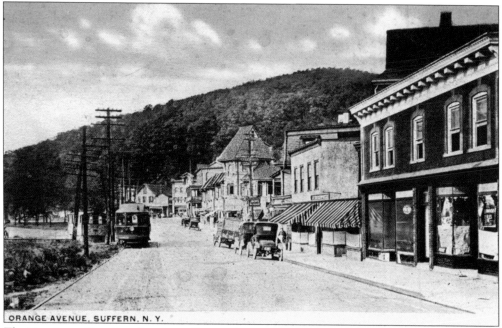

ORANGE AVENUE, SUFFERN, N. Y.

The New Jersey Transit trolley sits on Orange Avenue, ready for its next run in this *c.* 1926 postcard. Trolley service ceased in 1929, but it was not until 1932 that the Public Service Commission allowed the old rails to be removed so the highway could be widened its entire length to the New Jersey state line.

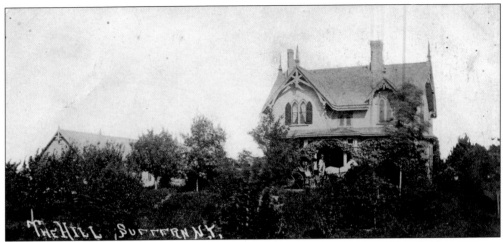

With demand for seasonal housing increasing, Thomas W. Suffern opened his Gothic mansion on the hillside that overlooked the village and the Ramapo Mountains. Built in 1863, the house was popular with tourists, offering reasonable rates and a wide sweeping porch. Following Suffern's death in 1905, the home was turned into apartments. While being renovated in 2000, it was destroyed by an arson fire.

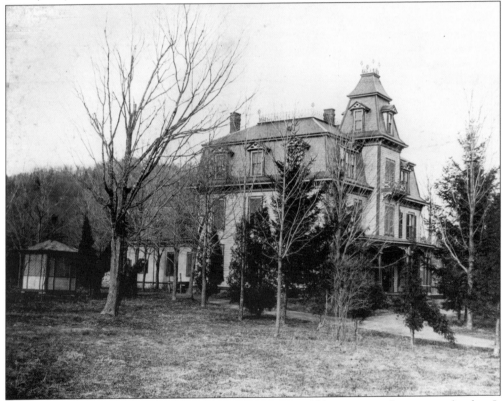

Charles E. Suffern built this Second Empire–style mansion in 1876 to accommodate summer borders. It had an imposing setting on Lafayette Avenue, with Lake Antrim at its back door. When purchased by Judge Edgar Tilton, it was named Brookside. Guests were sometimes inconvenienced when the judge held court in the parlor. In 1936, Avon purchased the mansion and razed it for a parking lot.

Built as a toll road in the 1830s, Nyack Turnpike extended across the county from the hamlet of Ramapo to the shipping docks at Nyack. In this 1910 postcard, a carriage rides east past the location of a former tollgate. Although greatly widened from its earlier dirt roadway, the busy state highway today is still bounded in spots by stonewalls.

After the incorporation of the village, the road from Haverstraw was named Wayne Avenue. To the right of the wooden guardrail lies Lake Antrim. Set against the Ramapo Mountains is the large, picturesque home of New York businessman Edmund J. Conrad. In 1962, the site became home to 140 apartments in the new Berkeley Square complex.

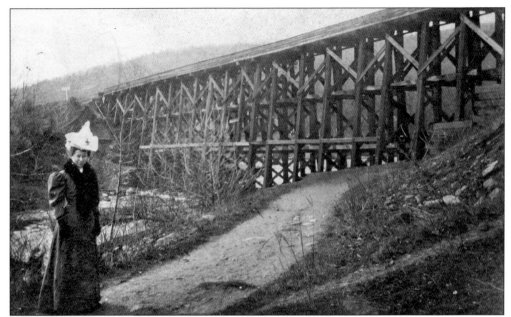

A women stands in front of the massive timber frame trestle that carried the Erie Railroad's Piermont Branch over the Mahwah River in Suffern. The original double-arch span was made of stone. It was washed away in a November 1878 storm and replaced by this 200-foot wooden trestle that stands 50 feet high.

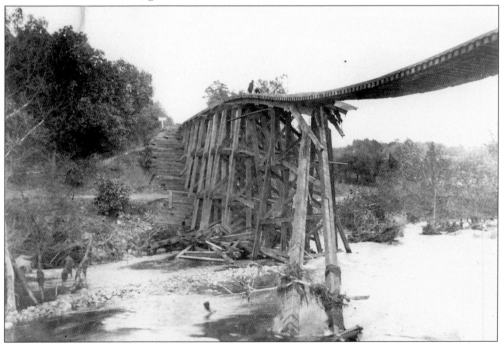

The October 1903 flood in the Ramapo Valley is captured in this image of the mighty railroad trestle that was wrecked by the storm. As 10.5 inches of rain fell over a two-day period, the dam holding Lake Antrim gave way. The surging water smacked into the heavy wooden support members of the trestle, causing a collapse. The rails and ties were left suspended over the swollen river.

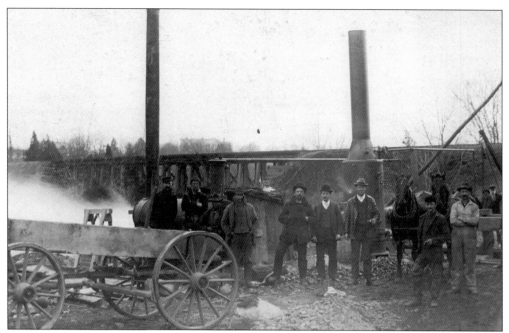

Following the disastrous October 1903 flood, brothers Albert and John Shuart assemble a work crew to assist the Erie Railroad with repair of the Piermont Branch trestle. The floodwater broke the damn at Lake Antrim, knocking out the wooden bridge. When this photograph was taken, the trestle (in the background) had been repaired and the men pause before continuing cleanup efforts.

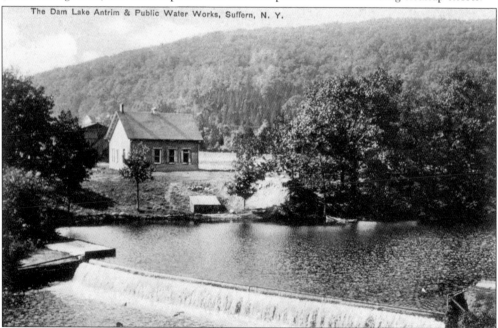

The Dam Lake Antrim & Public Water Works, Suffern, N. Y.

This postcard scene of the dam at Lake Antrim was taken after it was repaired following the 1903 flood, in which it collapsed and was washed away. The small building was the pump house for the village's water works department. The flat area to the right of the building would become A. E. Bird's Washington Circle housing development in 1928.

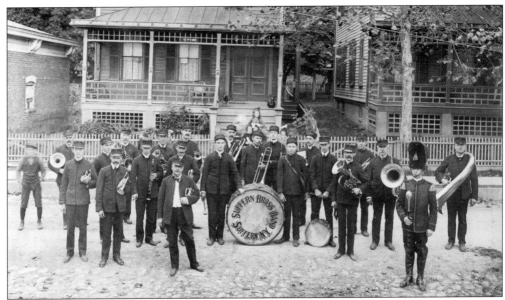

The Suffern Brass Band was organized in October 1901 with a membership of 24. Under the instruction of Prof. A. H. Travers and the leadership of Oscar Heddy, the band could be engaged wherever "first class music was required," according to their advertisement. The musicians boasted a repertoire of several hundred selections. Rehearsals were not missed, "with the exception of an occasional stormy night in the winter."

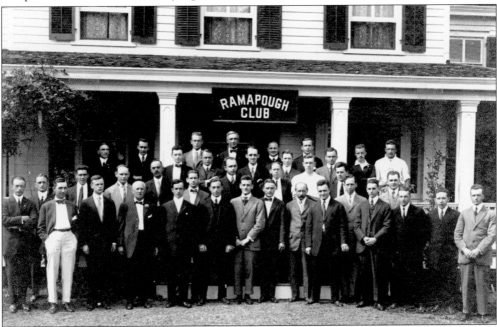

Gathered in front of their headquarters, the old Suffern homestead on Lafayette Avenue in 1916, are members of the Ramapough Club. On November 3, 1913, twenty-four young men met to create an organization to provide a place for young Suffern men to "put some ginger in the social life of the community." Tennis courts were constructed, and dances, lectures, and billiards were offered as entertainment.

The chief of police, John Lidster, stands in the doorway of Rogers Drugstore in this 1913 photograph. Roscoe Jones (with the pompadour) and James Cullen stand beside him. Lidster was the night police officer and became chief following the sudden death of William N. Smith in 1912. Serving only two years, he left to open Jack's Chop House on Orange Avenue.

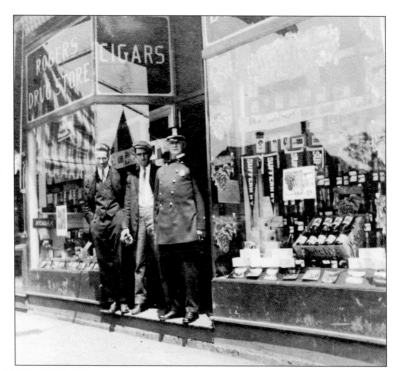

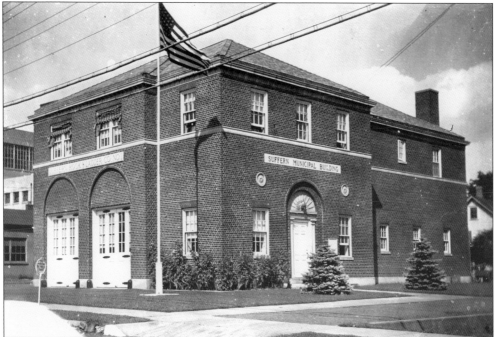

The Suffern Municipal Building was formally opened on May 4, 1929, with more than 1,000 in attendance. Considered to be "the most progressive step taken by any village," the new $50,000 hall on Washington Avenue combined all services under one roof, which included village offices, police department, jail cells, justice court, and two bays for fire trucks. Robert R. Graham was the architect.

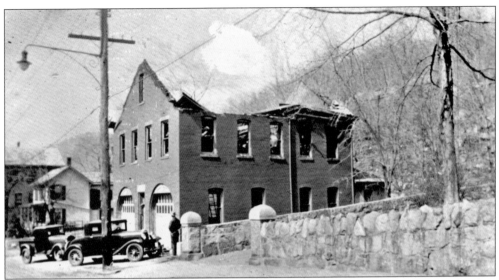

A disastrous blaze struck the Wayne Avenue firehouse in the morning of March 27, 1934. Two pumpers were rescued from the building, as was a prisoner who was in the village lock-up. A year later, a new firehouse was built on the same site for $16,500. In October 1995, the volunteers dedicated a new building when the hose company moved to Washington Avenue. (Goetschius Collection.)

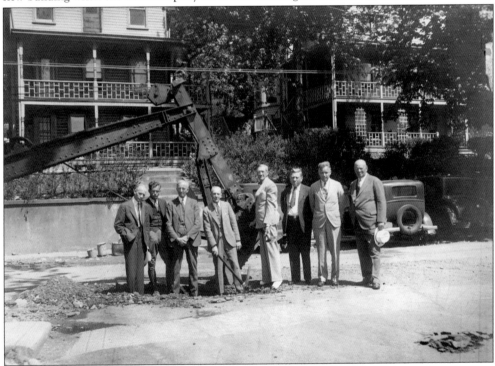

Shovel in hand, Suffern mayor Frank Dunnery broke ground on May 23, 1934, signaling the start of the village sewer extension project on Wayne Avenue at Cross Street. Those pictured are, from left to right, trustee George W. Unsworth, M.D.; engineers Charles A. Pohl Jr. and Charles A. Pohl Sr.; trustee Frank S. Barnes, who is holding the axe; Mayor Frank Dunnery; trustee August Temple; village attorney Morton Lexow; and contractor Joseph L. Sigretto.

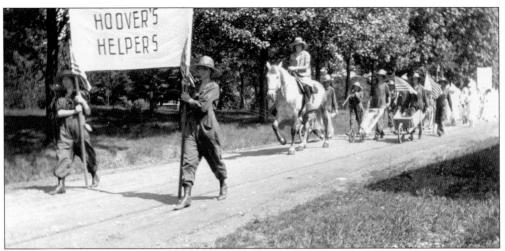

In 1917, young "Hoover's Helpers" parade down the street with wheelbarrows in tow in Suffern. They were responding to a nationwide call by Herbert Hoover, head of the United States Food Administration, for American housewives to conserve and protect the food supply. Going from house to house, mothers and children collected surplus provisions because "food will win the war" in Europe. (Suffern Free Library.)

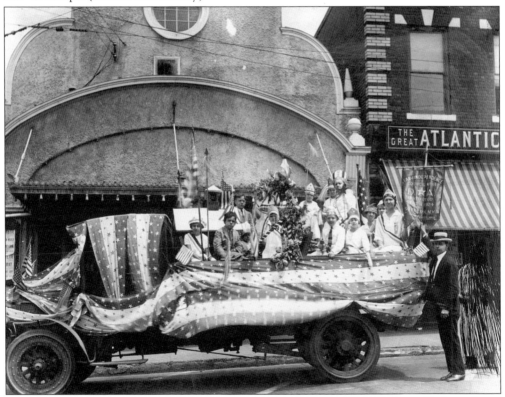

This patriotic float, parked on Lafayette Avenue, was the handiwork of the Star of Independence Council for the Daughters of America in Suffern. It was part of the July 4, 1926, parade. On the far right side of the photograph, a figure is etched-out of the image with black ink. The subject removed was a member of the Ku Klux Klan. (Goetschius Collection.)

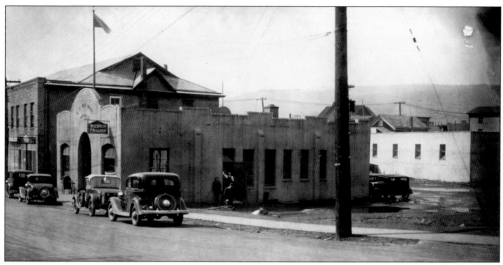

Prior to 1925, Suffern's post office was housed in various stores downtown. As with any federal appointment, the local postmaster, often a local merchant, was subject to change. With each new administration, the mail bags moved from store to store. In the spring of 1925, business partners Frank Maloy and Lewis Chatfield built the masonry building, seen in the photograph above, on Chestnut Street to house Suffern's first stand-alone post office. Ten years later, as part of the work relief program sweeping the country, hundreds of new post offices were constructed. Suffern would benefit too. The image below shows the start of construction in March 1936 of the new post office on the site of the former building. It was opened November 7, 1936, and cost $36,000. (Both, United States Postal Service.)

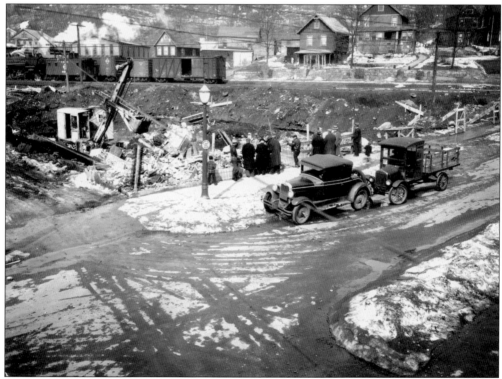

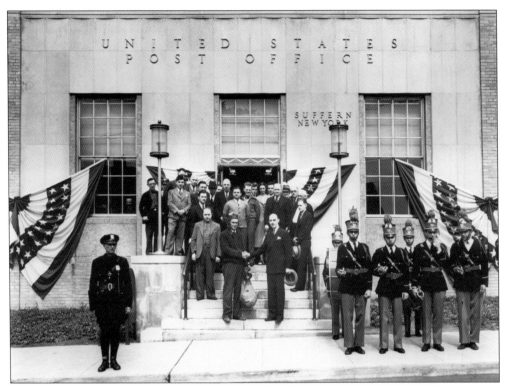

The first airmail flight direct from Suffern became history on May 19, 1939, when 19-year-old Joseph "Mike" Sheehan Jr. loaded a satchel containing 720 pieces of mail into his airplane. He took off from Kakiat Airfield, a tomato field that was located on the Sheehan farm outside Suffern. Before the take-off, a ceremony was held on the front steps of the Suffern Post Office.

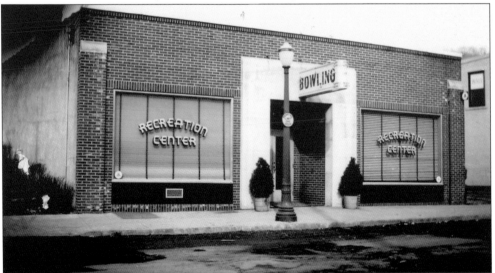

The Recreation Center, at 29 Chestnut Street, was opened on November 12, 1938. Owners Nick Carissimi and David Greenstein hired architect George E. Fowler to design the six-lane bowling alley. Gaining in popularity, two years later, they added four more lanes. When in Suffern, Yankee legend Babe Ruth was a frequent bowler there. A January 1968 fire delivered the final strike to the lanes.

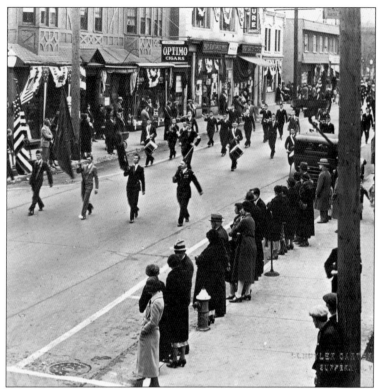

The American Legion Post 859 Drum and Bugle Corps made its first public appearance marching down Lafayette Avenue in 1938. They were part of a parade that was celebrating the Nation Recovery Act, the federal program that was enacted after the Depression. Suffern residents, like so many others across the nation, hoped new jobs would be created to help the many unemployed.

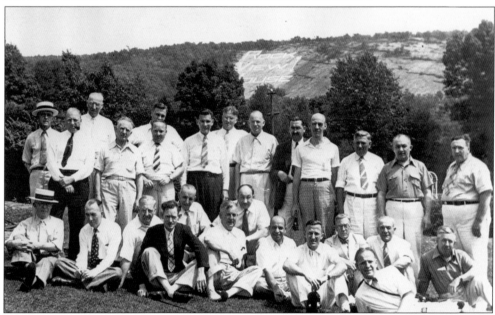

Here in 1939 are the members of the Suffern Rotary Club at their annual outing at the Rock View House on the Delaware River in Montague, New Jersey. The day was "pleasantly spent" playing golf, tennis, softball, or cards or bathing in the sun or water. Organized in 1927, the Rotary Club's roster has been, and remains, comprised of community luminaries who are committed to the ideal of service above self.

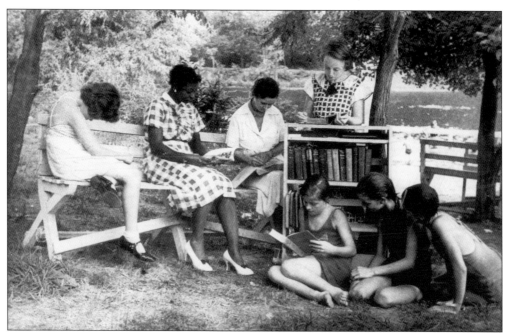

A summer reading group enjoys books under shady trees along the shore of Lake Antrim. During a July 1937 heat wave, Suffern Free Library decided to create an "open-air branch." The program was a huge success. At times, more than 50 children left the water to read or have a story read to them. The outdoor library continued until the start of World War II.

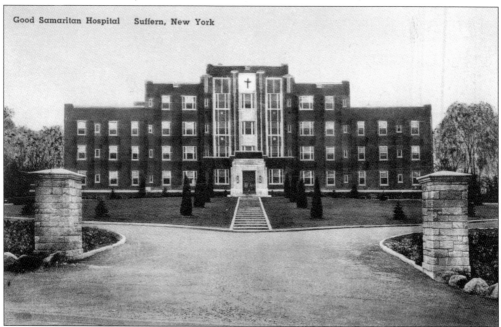

Good Samaritan Hospital opened its new facility at the upper end of Lafayette Avenue on November 1, 1938. The new hospital, under direction of Sr. Regina Cecilia, was built at a cost of $600,000. It contained 80 beds, more than double the capacity of the old mansion. Maternity and nursery rooms were on the third floor, so as not to disturb other patients.

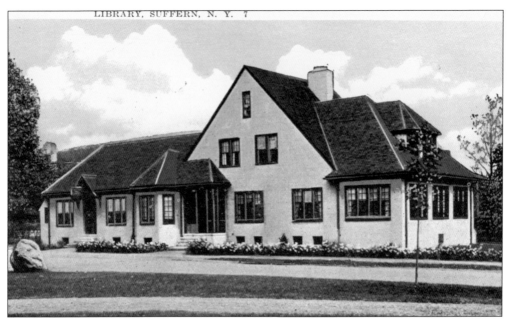

This Tudor-style building was the clubhouse for the Suffern Woman's Club, located on the northeast side of Lafayette and Washington Avenues. In 1920, sixty women gathered to form a center for social, cultural, and civic activities. Federated in 1921, they built their clubhouse in 1924, which provided a home for Suffern's first library. Very active today, the organization carries on its tradition of cultural activities and fund-raising.

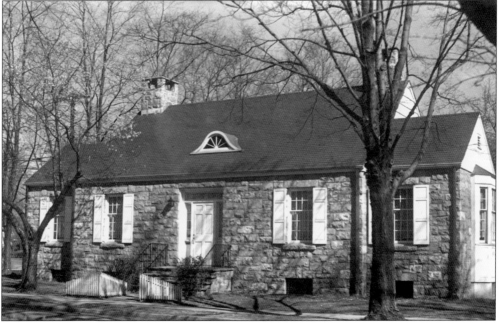

On Saturday, December 7, 1941, more than 200 people celebrated the opening of the Suffern Free Library's building, located on the corner of Maple and Washington Avenues. The small stone structure cost $16,252 to build and held 6,500 books; an adult wing was added in 1967. The library moved in 2000 to a new 37,000-square-foot building on Lafayette Avenue. (Suffern Free Library.)

Five

ON THE OUTSKIRTS
OF TOWN

Suffern had become an important station on the main line of the Erie Railroad. New Yorkers in search of a cool, quiet retreat filled the trains bound in summer for the surrounding rural regions. Relatively isolated prior to the 1860s, Suffern served as a welcome mat for the upstate Erie traveler. Close to 20 trains a day, loaded with seasonal tourists, stopped at the impressive Victorian depot. According to the *Rockland County Journal*, word soon spread among travelers that "romantic scenery, fascinating beauty, and rich land" could be found at this "pleasant summer resort." Suffern played host to the traveling public, whether accepting the hospitality of hotels and boardinghouses, or just switching trains.

The list of guests, visitors, and part-time residents attracted to Suffern's rural charm included many families from New York's affluent upper crust. Some came as seasonal vacationers, renting estates, while others bought parcels of the wide open, undeveloped land. Picturesque rolling hills and vast woodlands, guarded by the Ramapo Mountains, provided a rustic setting for an elegant, new country estate.

Suffern continued to absorb visitors, both seasonal and permanent residents. The hamlet's year-round population reached 500 by 1870, as a growing number of summer visitors established permanent homes. The broad streets, attractive houses, prosperous farms, and many "well-appointed" country estates enticed bankers, lawyers, businessmen, and employees of the railroad to join others who found homes in Suffern or on the outskirts of town.

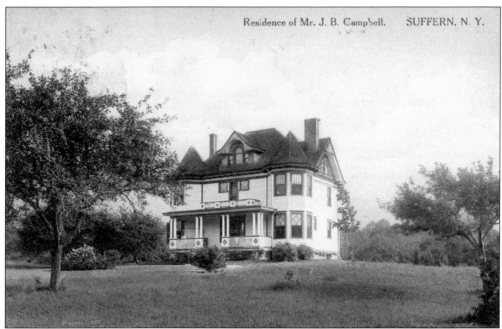

Suffern druggist James B. Campbell's success is reflected in the impressive wood and shingle home he built in 1907 on 12 acres on Montebello Road. A large barn and garage were added later. Before he relocated to the outskirts, Campbell resided in a smaller home close to his drugstore.

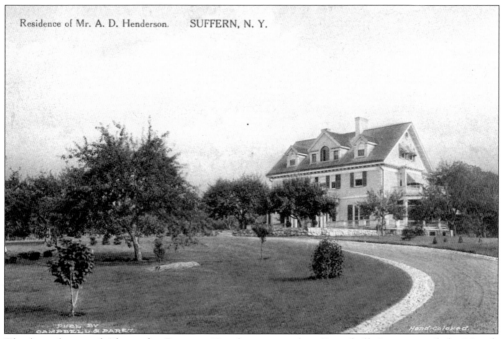

Residence of Mr. A. D. Henderson. SUFFERN, N. Y.

The large home of Alexander Dawson Henderson stood at Campbell Avenue and the Nyack Turnpike (Route 59). Henderson started as a bookkeeper in New York City with the California Perfume Company (now Avon Products, Inc.), working his way up to vice president and treasurer. After several summers in Suffern, he decided to build this home in 1906. It was razed in 1941.

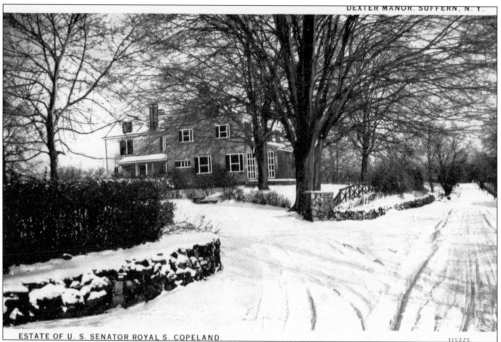

ESTATE OF U. S. SENATOR ROYAL S. COPELAND

Dexter Manor on Haverstraw Road was the summer home of Dr. Royal S. Copeland, the only U.S. senator to live in Rockland County. He served as a senator from 1928 until his death in 1938. The large Colonial home, just west of Viola Road, was named after Dr. Copeland's birthplace in Dexter, Michigan. A physician, he began his political career in New York City as commissioner of public health.

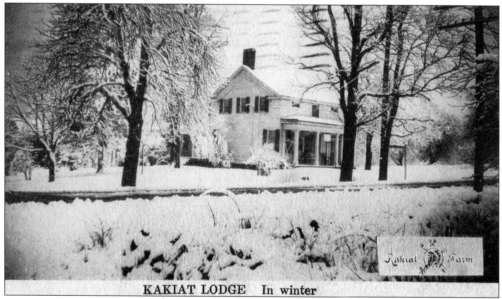

KAKIAT LODGE In winter

Built around 1830, this Greek Revival home was originally owned by the Blauvelt family. It was part of a large farm on Haverstraw Road, with property stretching to the Mahwah River. Aaron Blauvelt had a saw and grist mill and later added a foundry, making plows and other farm tools. In later decades, the house was a popular tourist inn named Kakait Lodge.

81

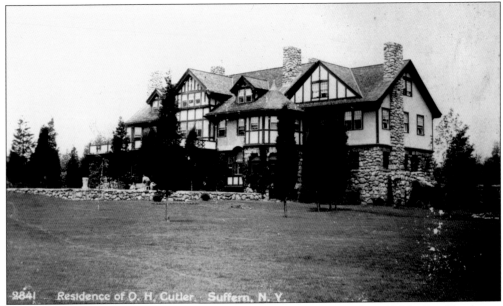

This is Rockrest, a notable English Tudor mansion that was constructed in 1906 for Otis Henderson Cutler. It was located at the upper end of Lafayette Avenue, near Hemion Road. Cutler, a former New York state assemblyman, was president of American Brake Shoe and Foundry Company in Mahwah, New Jersey, and a director of more than a dozen New York City concerns. The home was destroyed by fire in 1968.

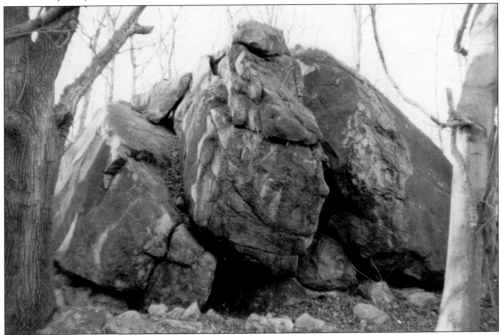

Across Hemion Road was Cutler's Boulder Farm. It is easy to see why. This 17,300-ton Proterozoic granite gneiss rock was deposited during the Ice Age, about 21,000 years ago. The boulder was a meeting site for Native Americans thousands of years before European settlers arrived. Over time, this landmark was called Indian Rock and now is a feature in the landscape of a strip mall.

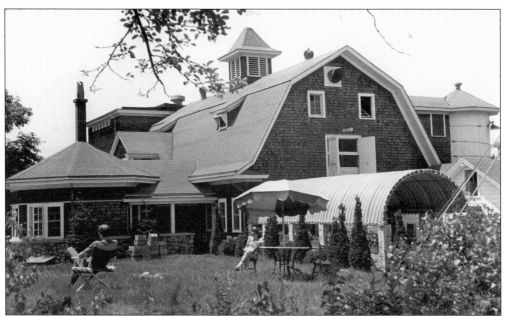

In the summer of 1933, Cutler's son Robert Frye Cutler converted Boulder Farm's massive dairy barn to a playhouse that was called the Suffern County Theater. His ambitious plans included transforming it into a 250-seat theater, complete with exhibition hall, tearoom, restaurant and bar with outdoor dining, and workrooms for classes in arts and crafts. The Suffern County Theater soon ranked among the top five summer stock theaters in the country. Sets for about 10 performances a season rivaled those found on Broadway. The casts included the following big names in show business: Helen Hayes, Joshua Logan, Jean Muir, Jose Ferrer, Ruth Gordon, Madge Evans, Gregory Peck, and Vincent Price, just to name a few. Closed during World War II, it was reopened until 1949, when it was closed permanently.

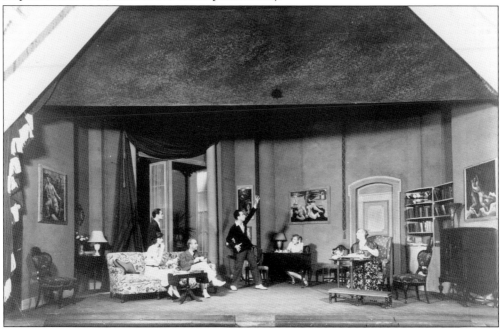

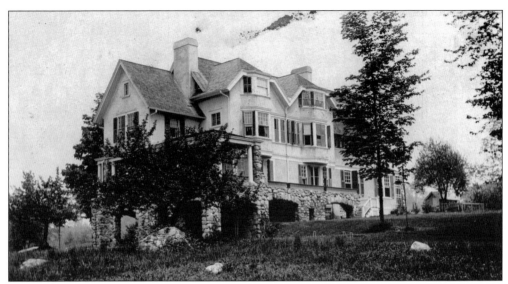

In 1907, prominent New York City attorney Robert Chetwood Beatty engaged architect Josiah T. Tubby Jr. to design a country home on 54 acres at Montebello and Airmont Roads. The stone and stucco mansion contained 17 rooms, four bathrooms, and a wide porch that offered views of the Ramapo Mountains. Originally called Pine Tree Farms, the property is now Montebello Pines subdivision.

Often referred to as the Aaron Burr cottage, this small clapboard farmhouse on Montebello Road was subject to much "historical romance" before it was razed by fire in 1985. While Burr was a lieutenant colonel stationed in the area during the American Revolution, he met his wife, Theodosia Provost, whose family owned thousands of acres, including this site. Local lore says the couple stayed there while in the area.

In 1934, nationally known author, economist, and philosopher Ralph Borsodi established the Bayard Lane community, an experimental cooperative. Homesteaders, mainly New York City commuters, built houses of native fieldstone and followed Borsodi's method of agrarian self-sufficiency, raising chickens and goats and tending gardens. It taught "Decentralist Theory," family strength via economic independence.

This cobblestone barn, built with stones cleared from the field in 1910, was the centerpiece for Henry von L. Meyer's working farm, a 200-acre estate on Viola Road. Meyer was founder and vice president of White Laboratories in Newark, which made remedies such as Feenament and Aspergum. Known for philanthropy, Meyer family members were ardent supporters of many local charities.

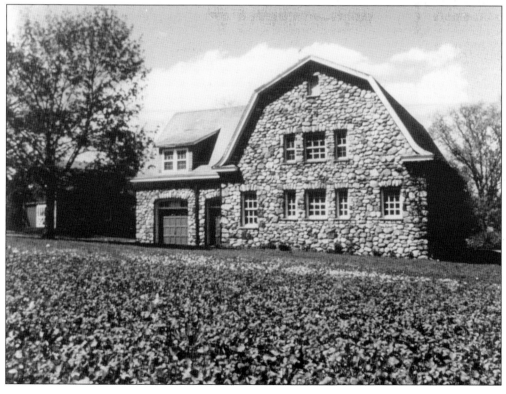

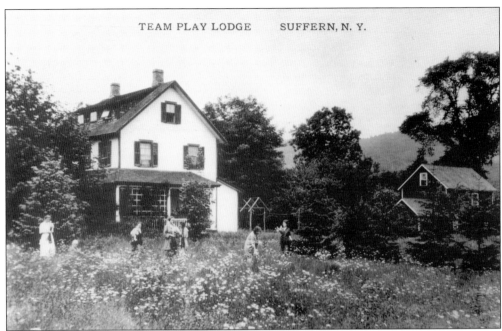

TEAM PLAY LODGE SUFFERN, N. Y.

The Team Play Lodge on Montebello Road was the farmhouse of the Fredericks family. In 1920, the Blind Players Club, a group of blind women from Brooklyn, bought the 10-acre property. They used it as a vacation spot and presented dramatic performances to raise funds for projects on behalf of the blind. A swimming pool and buildings later served blind children.

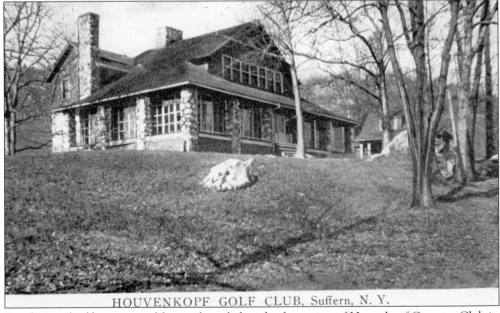

HOUVENKOPF GOLF CLUB, Suffern, N. Y.

Popularity of golf among wealthy residents led to the formation of Hovenkopf Country Club in 1906. The course was actually over the state line in Mahwah, New Jersey, but most advertising and postcards claim Suffern as its location. The once-fashionable club ultimately failed and in 1953 was purchased by Ford Motor Company for an assembly plant, now replaced by the Sheraton Mahwah Hotel.

Dr. Paul Gibier, a French-trained engineer, physician, and director of the Pasteur Institute in New York City, purchased a 183-acre farm in 1895, located along Nyack Turnpike. Credited with bringing Pasteur's lifesaving treatment for rabies to this country, Dr. Gibier established a "Pasteur Farm" on Suffern's outskirts. Animals were kept and bred for research and the production of antitoxins. In 1898, a large wood and stone frame sanatorium was built to care for patients, especially those suffering from tuberculosis, or "consumption," as it was then known. Plans were under way to expand the facility when, in June 1900, Dr. Gibier was killed in a runaway carriage accident, ending a brilliant medical career and hope of further contributions to medical science.

Daniel Carter Beard, a founder and first commissioner of the Boy Scouts of America, has local scouts gathered at his home in Suffern to celebrate his 89th birthday in 1939. Beard moved to Suffern in 1928, purchasing the 13-acre estate, Brooklands, along the Mahwah River. The grand center-hall Colonial home featured walnut paneling, servant's quarters, a greenhouse, and a garage with a turntable. The wooded estate was host to many scout troops, gathered at various times for personal lessons in the outdoor way of life. "Uncle Dan," as he was affectionately known, died at his home in 1941, just shy of his 91st birthday. Scouts lined the funeral route from his home to the cemetery at Brick Church.

Which Coe house was it? That question is often asked when trying to establish where composer John Philip Sousa stayed when he came to Suffern in 1898. News accounts report Sousa taking possession of the "A. Coe" house on Haverstraw Road for the summer. The problem is that both homes pictured belonged to an A. Coe, Andrew (above) and Augustus (below). Both took in summer boarders and lived across from each other on Haverstraw Road. Both family branches claim the bragging rights. Not in dispute is the fact that while Sousa and his family were in Suffern, they enjoyed the area, and at his desk on the front porch of the Coe house, the composer wrote the lyrics and music for "The Charlatan," produced in Montreal that fall.

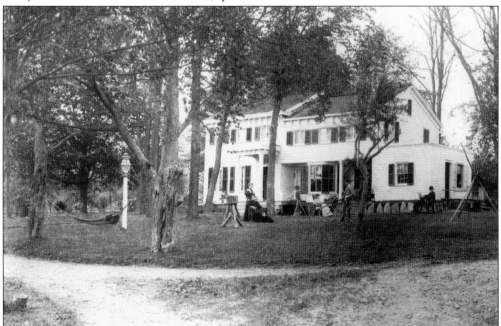

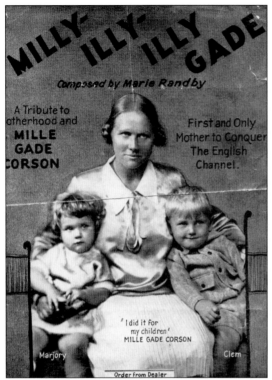

A year after swimming across the English Channel on August 27, 1926, Mille Gade Corson and family bought the Reding farm on Campbell Avenue. This sheet music, showing her children Marjory and Clemington, was composed as a tribute to her as the second women—but first mother—to swim the channel. When asked about her accomplishment, Corson simply said, "I did it for the children." (Suffern Village Museum.)

Gloria Hollister, scientist, explorer, and conservationist, stands with Dr. William Beebe and John Tee Van. Hollister became the first women to descend to a depth of 1,208 feet in a bathysphere on August 15, 1934. Hollister came to Suffern as a baby in 1903 when her father, Dr. Frank C. Hollister, purchased the home of Maj. Thomas T. Lloyd on Haverstraw Road. The frame dwelling remains, but the original driveway has been altered to create a private road, Colline Drive.

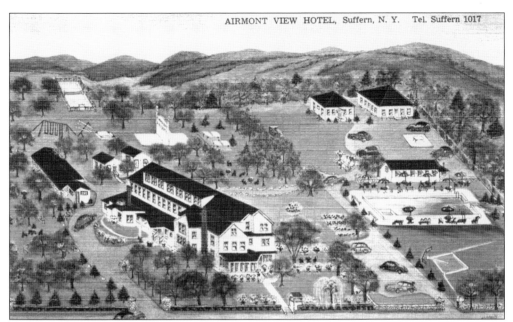

In the 1920s, Samuel Smith opened his home on Cragmere Road for summer boarders. As the popularity of his Airmont View House grew, so did his offerings. The main house was expanded to a three-story, 51-room hotel. Large bungalows were constructed, as well as a swimming pool, tennis courts, baseball diamond, and other recreational facilities. Ramapo Manor Nursing Home was built on the site in 1956.

The administrative offices for Rockland Community College originally housed the county almshouse. It had been the site of the Brick Church parsonage farm until 1837, when it was sold to the commissioners of the poor to house the county's poor, homeless, and sometimes insane. When the college was established in 1959, the infirmary, as it was known then, moved to Summit Park.

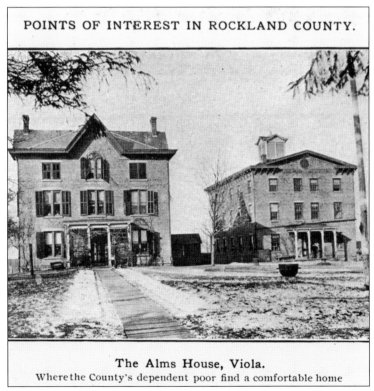

POINTS OF INTEREST IN ROCKLAND COUNTY.

The Alms House, Viola.
Where the County's dependent poor find a comfortable home

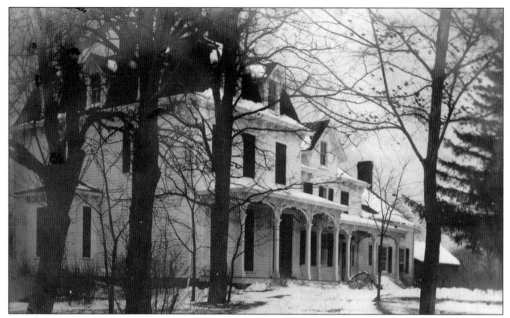

This winter scene of Joyland, the country home of the Joy family on Viola Road, was photographed in 1910. Built by the Coe family, the large frame house and extensive property was purchased by New York businessman John B. Joy in 1902. When Joy died in 1933, the estate was sold and the property subdivided. The new owner spent $20,000 remodeling the home and rotating the structure 180 degrees.

The Mahwah River flows south, meandering along the stone-lined bank, adjacent to orchard fields. An iron truss bridge carried Montebello Road over the river, near Lake Road. It was replaced in 1936 by a stone span that is still in use today. In the background is the home of Eugene B. Wanamaker, built about the time of the Civil War. To the far left is his blacksmith shop.

ABSOLUTE AUCTION SALE

VIEW OF LAKE ANTRIM AT "ANTRIM TERRACE"

97 Choice Plots "ANTRIM TERRACE"
SUFFERN, N.Y.

To be sold on the Premises **Saturday, May 22, 1920** In Mammoth Tent

AT 2 P.M., RAIN OR SHINE

BRYAN L. KENNELLY REAL ESTATE AUCTIONEER

Choice real estate in a very desirable section of Suffern was offered for sale to home seekers, investors, and speculators in this 1920 brochure. Antrim Terrace was a flat and level property, overlooking Lake Antrim. The Suffern Development Company created the tree-lined streets of Lexington, Utopian, Chadick, and Crane Place. Within the next few years, attractive brick and wood-framed homes filled the neighborhood.

In the summer of 1925, T. Scott Widdicombe began laying out Buena Vista Heights, a development on the former Allan Ryan estate. Billed as Suffern's master suburb, the design for new homes would feature "cozy English cottages" of fireproof construction. A number of prominent Suffern businessmen purchased the attractive homes, leaving the downtown area. With the onset of the Depression, the development faltered, and Widdicombe abandoned the project.

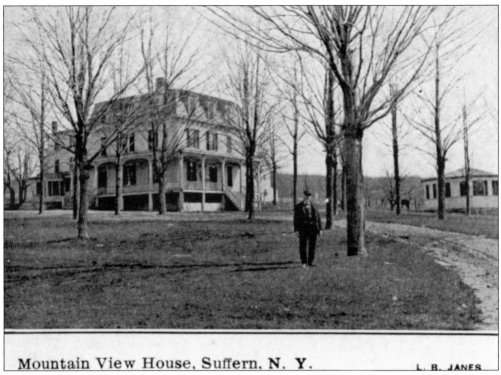

Mountain View House, Suffern, N. Y.　　　L. B. JANES

One of the first settlers in the Suffern area about 1690 was the German family of Philip Fox. He established a modest stone dwelling on a hillside tract in 1726. By the 1870s, David Fox developed the property, erecting "a large and beautiful boarding house with a splendid view of the countryside," as stated in the *Rockland County Journal*. Aptly named Mountain View House, it could accommodate nearly 100 guests.

The former Fox estate was turned into the development named Foxwood Manor. The 30-acre property, along the New Jersey border, was annexed into the village in 1954. Two years later, 30 homes were under construction in Suffern's first large-scale housing development. These nearly completed homes on Maplewood Boulevard were advertised as three-bedroom, split-level homes complete with all city improvements, starting at $16,250.

94

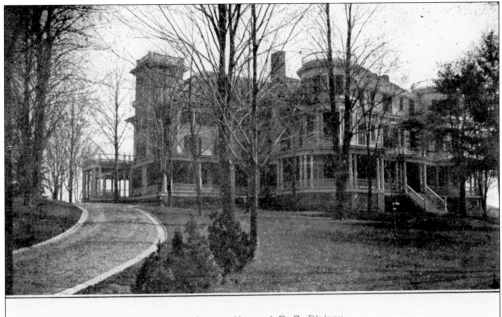

The Country Home of F. C. Dininny.

Since the 1860s, a number of wealthy families occupied this hilltop on Lafayette Avenue that overlooked the village. An elegant Italianate-style mansion had been built by a stockbroker and later was home to the first Catholic worship services. Among the home's owners were a Civil War hero and a businessman, Ferral C. Dininny Jr. His massive 1899 Queen Anne–style renovation added four cylindrical towers and a sweeping veranda.

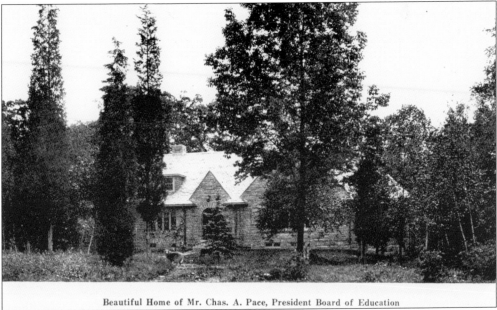

Beautiful Home of Mr. Chas. A. Pace, President Board of Education

Behind the stately trees is the large stone home of educator, lawyer, and banker, Charles A. Pace. The property, situated on 211 acres off Montebello Road, served as grazing land for a large dairy herd. Pace's Mill Cottage Farm was known for its milk, butter, and eggs. Aside from founding Pace University, he was prominent in civic affairs. The home is now the clubhouse for a homeowners' association.

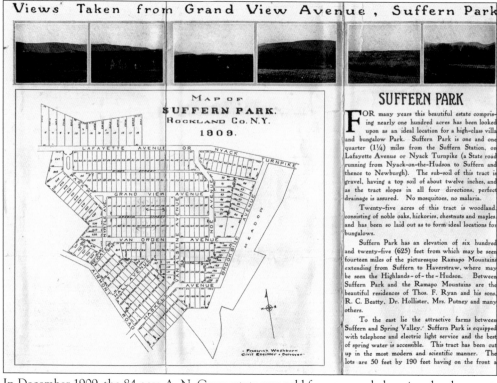

MAP OF
SUFFERN PARK.
ROCKLAND CO. N.Y.
1909.

· Frederick Washburn
Civil Engineer · Surveyor ·

SUFFERN PARK

FOR many years this beautiful estate comprising nearly one hundred acres has been looked upon as an ideal location for a high-class villa and bungalow Park. Suffern Park is one and one quarter (1¼) miles from the Suffern Station, on Lafayette Avenue or Nyack Turnpike (a State road running from Nyack-on-the-Hudson to Suffern and thence to Newburgh). The sub-soil of this tract is gravel, having a top soil of about twelve inches, and as the tract slopes in all four directions, perfect drainage is assured. No mosquitoes, no malaria.

Twenty-five acres of this tract is woodland, consisting of noble oaks, hickories, chestnuts and maples, and has been so laid out as to form ideal locations for bungalows.

Suffern Park has an elevation of six hundred and twenty-five (625) feet from which may be seen fourteen miles of the picturesque Ramapo Mountains, extending from Suffern to Haverstraw, where may be seen the Highlands-of-the-Hudson. Between Suffern Park and the Ramapo Mountains are the beautiful residences of Thos. F. Ryan and his sons, R. C. Beatty, Dr. Hollister, Mrs. Putney and many others.

To the east lie the attractive farms between Suffern and Spring Valley. Suffern Park is equipped with telephone and electric light service and the best of spring water is accessible. This tract has been cut up in the most modern and scientific manner. The lots are 50 feet by 190 feet having on the front a

In December 1909, the 84-acre A. N. Crow estate was sold for an upscale housing development, just east of the village limits. Brothers John, Philip, and Percival Van Orden, along with brother-in-law Philip Van Alstine and realtor Alfred Hall, created Suffern Park. Stone pillars were the gateway to this "wisely restricted, high-grade bungalow and villa colony," an ideal location where homes ranged in price from $6,000 to $28,000.

Antrim Playhouse, a community theater, began in 1936 with a group of college students performing in school auditoriums while on summer vacation. The building on Spook Rock Road was originally constructed in 1916 for the community club. First renting in 1940, the Antrim Players purchased the playhouse in 1953. Many talented people, including Fred Gwynne, Tyne Daly, and Rene Auberjonois, had their starts here. The theater still operates today.

Six

A Place for Worship

Usually in a prominent location, a house of worship was viewed as an important part of any community's foundation. In America, they were architectural descendents of European cathedrals and smaller village churches. As Suffern began to grow and develop from a rural and relatively isolated area, so did the need for residents to congregate for spiritual guidance and worship.

The earliest settlers to the region, the Dutch, German, English, and Irish, brought with them various Christian faiths, mostly Protestant. These pioneers held services or prayer meetings in private homes that were scattered about the countryside. If they were fortunate, a horseback-riding circuit minister might pass through and offer his services to the faithful. By 1720, a modest rough-cut log structure served as a Lutheran prayer meeting house, located a short distance to the south, in Mahwah. A wood-framed Presbyterian chapel was erected in 1810 at the Ramapo Works, a few miles to the west. Services at these churches were somewhat irregular and fluctuated with the population. For Suffern residents, it was inconvenient to travel elsewhere to worship.

As the population grew, the people in Suffern wanted their own neighborhood churches. But it would take several decades before the first church bell rang. Just prior to the start of the Civil War, residents would meet in the home of George Washington Suffern. This gathering would lead to formation of a congregation that would build the first church in Suffern. In the years that followed, several other churches would be constructed, representing the cultural and architectural tastes of their members. Today, with an impressive legacy and history, these houses of God are a testament to the diversity of the community and the practices and experiences of those who first established them in search of a place for worship.

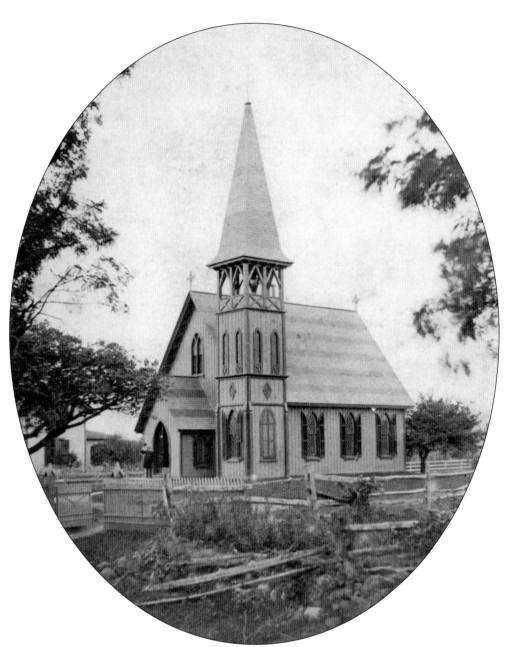

Christ Church of Ramapo was Suffern's first church. It was organized in 1860 when residents held services in the home of George Washington Suffern. Initially, it was to be a Dutch Reformed Church, but later worshipers decided it should be Episcopalian. A small Gothic Revival board-and-batten church was erected a year later by Henry Rehling on property donated by William D. Maltbie. The church bell hung in a nearby tree until 1871, when funds were raised for a bell tower. This image shows that steeple prior to a November gale in 1874, which toppled the tower. The bell tower was later replaced. In 1896, the parish hall became the meeting place for the movement to incorporate Suffern as an official village. In May 1902, descendents of Alexander Hamilton commissioned for the chancel a magnificent stained-glass triptych window, designed by Tiffany Studios.

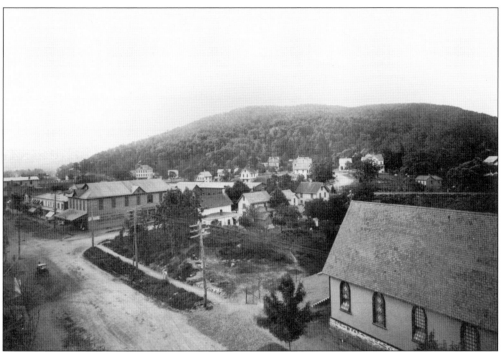

Area Catholics met in private homes for Mass prior to 1868. That summer, George Washington Suffern donated land for a Roman Catholic Church. A modest wood-frame building was constructed on Lafayette Avenue, opposite Park Avenue seen on the lower right of the early image above. It was dedicated on August 15, 1869, to St. Rose of Lima. When wealthy summer resident Ida Ryan, a devout Catholic, moved to Suffern in 1897, she paid for the installation of electric lights and steam heat. After several years, she felt the small church needed to be replaced. Ryan hired the architectural firm Schikel and Ditmars of New York City to design a new church. It was built at the intersection of Lafayette and Washington Avenues for $50,000, with an additional $20,000 for the elegant stained-glass windows. It was consecrated on September 26, 1903, and renamed Sacred Heart.

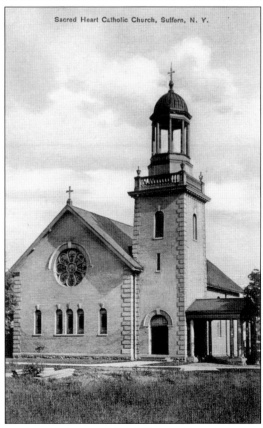

Sacred Heart Catholic Church, Suffern, N. Y.

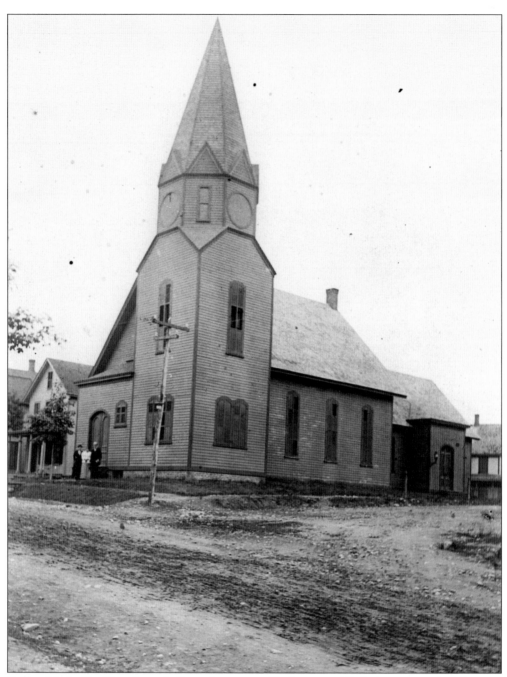

Suffern Methodist Church was built on the corner of Lafayette and Park Avenues, with dedication services held September 11, 1870. A steeple was added in 1889 and towered 75 feet over the business district's main street. The church bell, brought from England, served as the village's first fire alarm. In 1907, a new pipe organ was installed, with half the cost paid by philanthropist Andrew Carnegie. The church property was sold in 1920 to make way for a new Suffern National Bank Building. The building was moved up Lafayette Avenue by a team of oxen to a new location on Washington Avenue.

At its new location, the Methodist church (on left, without its bell tower) sat adjacent to the old Suffern homestead. The church purchased the distinctive home for use by the pastor and his family. In the summer of 1949, at a cost of $8,000, a new steeple, 46 feet high, was erected. When the Methodists moved again, they did not take the church with them. In 1975, the 105-year-old building was razed for a parking lot.

Plans to build a new Suffern United Methodist Church began in 1959. Two years later, the church accepted a generous gift from Fred L. Wehran, a developer from Mahwah. He donated 4 acres of land on Parkside Drive in Foxwood Manor. The old church and manse were sold in 1965. A fellowship hall, education wing, and modern sanctuary were built. Services in the new church started in December 1966.

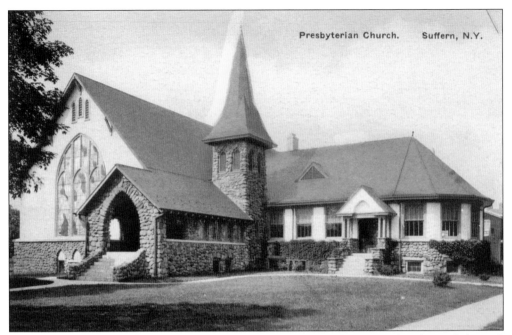

On Thanksgiving Day 1903, the stone chapel of the Suffern Presbyterian Church was dedicated. It was designed by New York City architect Charles N. Hoar and was built by local contractor Jacob B. Schultz for $4,413. The congregation started the previous year as a prayer meeting above the Suffern National Bank. The larger sanctuary, with a pipe organ and stained-glass memorial windows, was completed in 1921 at a cost of $47,300.

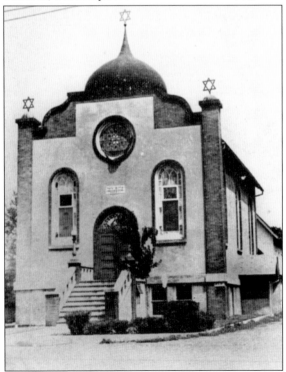

The religious, educational, and social needs of 30 Jewish families were realized on September 21, 1919, with the laying of the cornerstone for a synagogue on Suffern Place. The Hebrew Benevolent Society had held services since 1886. With the $25,000 temple, the society incorporated as Congregation Sons of Israel, with Jacob Friedman as its first president. In 1933, Rabbi Moses Rosenthal became the first resident rabbi.

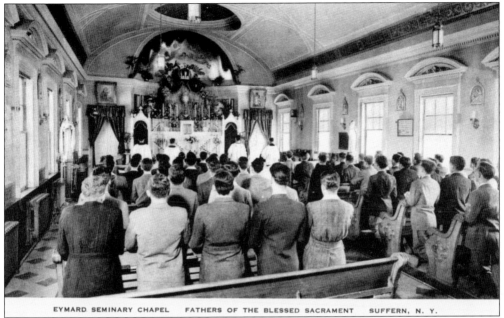

When the Fathers of the Blessed Sacrament opened Mount Eymard Seminary (today Tagaste Monastery) on September 20, 1904, fifteen boys studied for the priesthood. Within three years, the student population increased and so did the need for space. In 1907, construction began on the south wing, including this chapel, paid for by Thomas Fortune and Ida Ryan, in memory of their son, William K. Ryan.

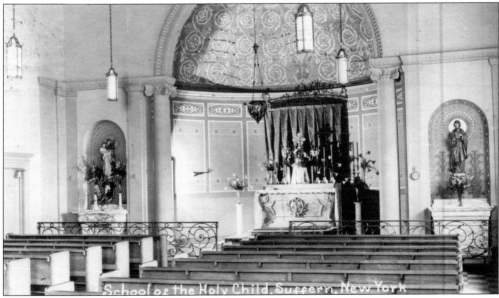

Attendance at daily religious services was mandatory at the School of the Holy Child (now the property of the Salvation Army). That is why the exclusive Catholic girls' boarding school engaged architect Robert J. Reiley in 1927 to design the chapel, gymnasium, laboratory, music rooms, and auditorium. The addition doubled the school's capacity, and more girls from prominent families joined the student body.

Construction began in the fall of 1928 on a small, but attractive, cedar shake building for the First Church of Christ Science, located at the corner of Antrim Place and Lafayette Avenue. It did not resemble a typical church edifice, and local residents referred to the building as a "gardener's cottage." The congregation started with meetings in private homes in the Suffern, Mahwah, and Ramsey, New Jersey, area. Eventually, the society moved to a room in the Suffern Woman's Club and later opened their new church on May 5, 1929. The congregation closed its doors in the late 1970s, and the property was purchased by Avon. The site was donated to the Village of Suffern in memory of Fred G. Fusee, a former chairman of the Avon Board of Directors and Suffern plant manager. The Suffern Hook and Ladder Company incorporated the church building into its design when it opened in 1982.

Seven

OBTAINING KNOWLEDGE AND EDUCATION

School bells did not ring in a public schoolhouse in Suffern until the early 1850s. Prior to that, most learning happened at home. In some cases, the church played a role in educating children. There is evidence that as early as 1840, a small school was located on Hemion Road, near the railroad crossing. But it was not until the state passed the first compulsory school law in 1853 that a building was constructed for Suffern scholars. It was a modest wood-frame one-room schoolhouse, measuring 32 feet by 22 feet with a 12-foot ceiling. It averaged 65 to 70 students a day, from kindergarten to the third grade. Many children left school after a few years, because they were needed on the farm or in a local business. As the years passed, several private schools were opened, but the average resident sent their child to public school. As the student population increased, so did the size of their school buildings. Wood-frame construction yielded to bricks and mortar. More children remained in school and completed their elementary education. Higher education was in demand, and a high school was established in 1905. From yesterday's blackboard to today's white board, the high standards set for Suffern's academic excellence are still in place today.

In October 1940, after a long and bitterly fought effort, Suffern and six smaller school districts in the western portion of Ramapo were consolidated. A 90-vote approval margin created the Ramapo Central School District.

The small Village of Suffern became home to several private and religious institutions of higher learning. The Mountain Institute, Herbart Preparatory, Ramapo Valley Day School, Suffern Military Academy, Rugby Military Academy, School of the Holy Child, and Mount Eymard Seminary are a few of the institutions that flourished in the shadows of the Ramapo Mountains, as students obtained knowledge and education.

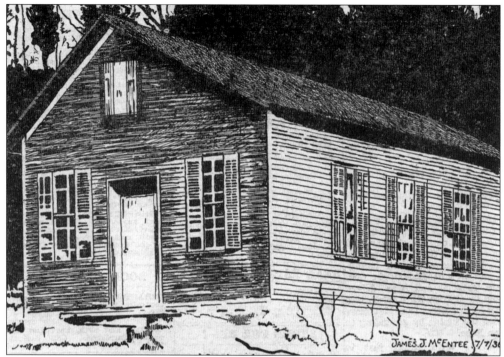

This artist's rendering shows Suffern's first schoolhouse, located among the cedar trees on Wayne Avenue. Constructed about 1853 by Peter Wanamaker, it sat on the north side of the road at the base of the mountain, between Cross Street and Washington Avenue. At one time, over 100 pupils were squeezed into the single room. It was abandoned in 1880, when a new school was built.

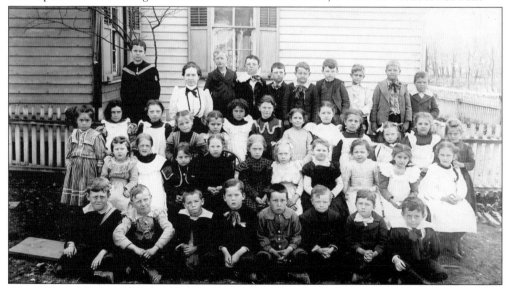

Anna Blauvelt's class of little scholars, shown in 1901, was the last group to pose on the front lawn of Suffern's second school, also on Wayne Avenue. With enrollment reaching almost 300 students, the five-room wood building was inadequate, forcing the district to rent classrooms at other locations. That summer, the old building was moved from the site and construction started on a new schoolhouse.

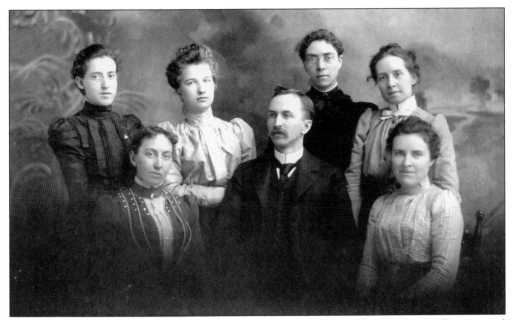

This was the 1899 teaching staff of the Suffern Union Free School District No. 3. The principal was Dr. Merton J. Sanford, a Suffern physician. His young faculty consisted of all single women, a preference in those days. Those women are, from left to right, (first row) Kate McGregor and Frances Patchin; (second row) Emma Telford, Harriet Churcher, Emma Robinson, and Anna Blauvelt. The annual school budget was about $2,500.

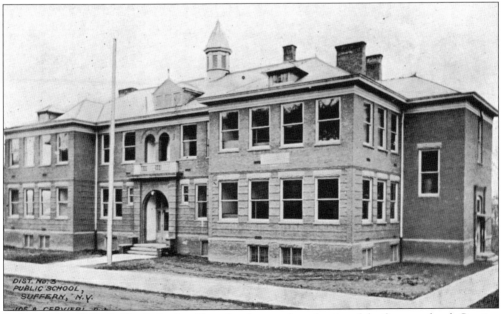

In September 1902, Suffern's third public school opened on the site of the former school. Costing $23,000, the large brick building could accommodate 400 students and contained 10 classrooms and an assembly hall. Soon there was the desire to have a high school. The New York State Education Department issued a charter in 1904, and the first graduating class of four students received diplomas in June 1905.

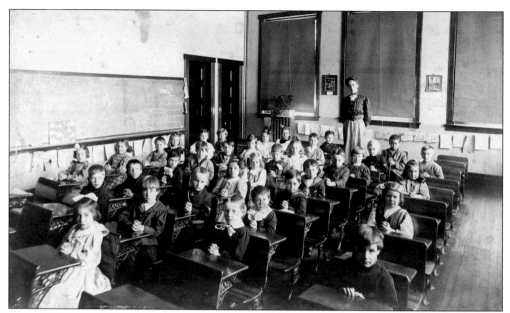

Hattie Telford and her class pause from their lesson on the Eskimo and the igloo for this 1900 photograph. The window shades are drawn to allow for an even exposure of light for the camera's glass-plate negative. Her second and third grade students, with their hands clasped on the desks, had to hold very still for a few seconds. Photographers usually had only one take.

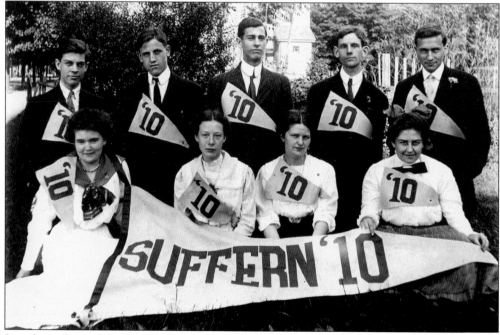

Proud members of Suffern High School's class of 1910 take a moment to pose prior to their commencement exercises. Family and friends "crowded" the Methodist church, where the graduation ceremony was held and diplomas were presented. Those pictured are, from left to right, (first row) Blanche Requa, Helen Wanamaker, Lizzie Hallett, and Mary Lee; (second row) James Knapp, Byron Barton, Wallace Cockran, Roy Springsteen, and Harold Davidson.

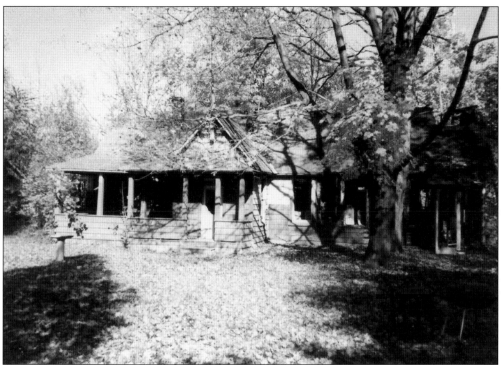

Thomas W. Suffern started teaching in his home in 1863. Word of his academic success spread, and by the summer of 1867, he constructed on his property a frame schoolhouse, called the Mountain Institute. In January 1880, Suffern accepted a principal and teaching position in Ridgewood, New Jersey, and closed his school. The building was remodeled for summer boarders. This photograph was taken in 1985, shortly before it was demolished.

RUGBY MILITARY ACADEMY, SUFFERN, N. Y.

DISMOUNTED TROOPERS.

Fourteenth year begins September 23d.

Preparation for all colleges.

Gymnasium, Laboratory, Athletic Field.

Infantry, Cavalry, Artillery.

For illustrated catalogue address the principal,

CLINTON OSGOOD BURLING.

Following the death of Dr. Gibier, his sanatorium was used as a summer boarding hotel and shared space with the Rugby Military Academy. Located at Central Park West, the school moved to Suffern for its "healthful and salubrious climate." The school boasted a strong academic program with military discipline. The country surroundings offered the cadets ample space for outdoor recreation, including infantry, cavalry, and artillery drills.

Callsthenics—Eymard Seminary. Suffern, N. Y.

Daily calisthenics were part of the structured life of these young men in training for the priesthood at Mount Eymard Seminary. The fathers of the Blessed Sacrament kept a close eye on them. When not engaged in bible study or other school-sanctioned activities, the boys could travel outside their stone-walled campus only when granted permission.

HOLY CHILD SCHOOL
SUFFERN, N. Y.

When taking a break from their rigorous academics, the girls at the Academy of the Holy Child could avail themselves of a number of amenities. The former country estate had 40 acres of lawn. Boating, tennis, field hockey, horseback riding, and picnics among the haystacks were just some of the ways students enjoyed their stay at this private Catholic school.

110

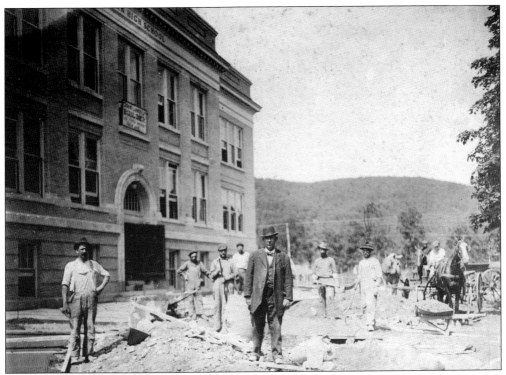

Workmen with the firm of John J. Lowry Jr. put the finishing touches on Suffern's new brick school in the summer of 1912. Overcrowding at the Wayne Avenue School necessitated building a separate structure for the high school. A lot was purchased on Washington Avenue, and the school, designed by architect Wilson Potter, was completed at a cost of $64,000 and opened that fall.

A big stage at the new high school on Washington Avenue was the perfect venue for this program by elementary students. On May 20, 1913, the young dancers demonstrated a minuet, complete with period costumes sewn by parents. Apparently, the boys were proud of their appearance. Only the names of male cast members were recorded. Pictured from left to right are William Peterson, Van Brown, Vic Kassner, and Lloyd Goetschius; (second row) Frank Schiekofer, Harris Conklin, Alden Smith, and LaRue DuVall.

Although not a championship year, the 1919 Suffern High School boys of the hardwood had a fun season. Games were played against area high schools and were a big attraction for residents. Those pictured are, from left to right, (first row) Gerald Donnelly, Ronald Becraft, Harold Jones, and Mike DiTore; (second row) Charles Miele, Clifford Washburn, and James Sherwood.

The Suffern High School baseball team won the county championship in 1928. Under coach Lou Whiting, the boys were undefeated, with a string of 10 wins. Slugging their way to the top, several players maintained impressive season batting averages of over .420. One student stole 22 bases.

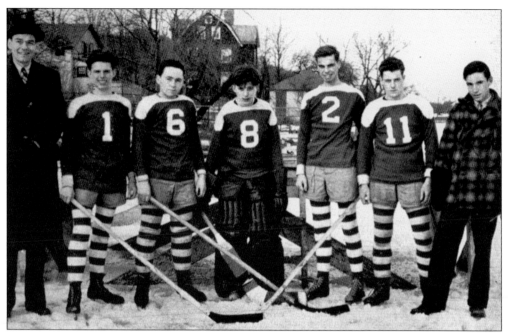

In the winter of 1939, Suffern High School students organized the first hockey team. They purchased their own equipment and practiced on Lake Antrim or found ice time on ponds on several large estates. It took the team just two years to reach the county championship. English teacher Tom Duffield managed the team, assisted by Bill Price, a coach with the New York Rangers.

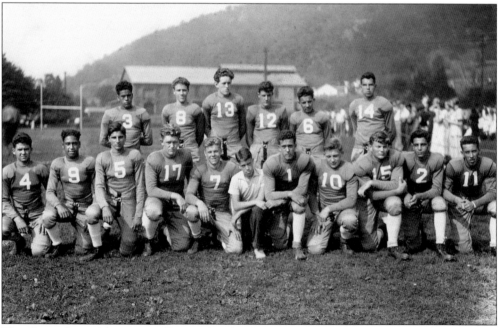

The 17 members of the 1938 Suffern High School football team assembled at the village's athletic field. This powerhouse team, under coach Ed Greene, would go on to finish four straight undefeated seasons, from 1938 to 1941, capturing the Rockland PSAL title. At the end of this four-year run, many players went off to serve in World War II.

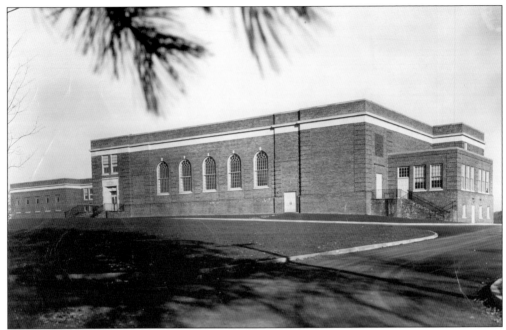

This image of Suffern's new high school on Hemion Road was taken just before it opened on September 8, 1943. A total of 702 students, from the seventh through the 12th grade, arrived that day, greeted by the 27 members of the faculty. A shortage of land downtown led to the district purchasing 40 acres on the outskirts of the village and building this $600,000 school.

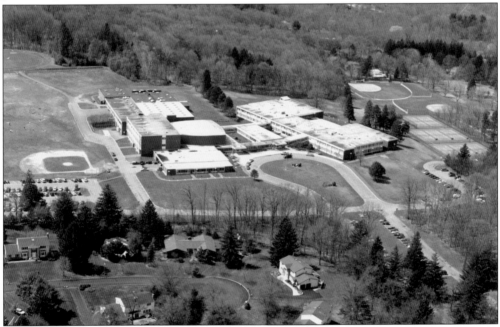

In December 1966, Ramapo Central School District voters approved a bond of $7.36 million to construct a 2,000-student high school on a 50-acre site, located at Viola and Mile Roads. The new Suffern High School would have 38 classrooms and include a planetarium, an Olympic pool, and an auditorium seating 1,200 people. The school opened September 9, 1971.

It was all smiles as Principal Richard P. Connor and excited students enter the new Cypress Road School on opening day, September 4, 1958. Built on 11 acres in the Buena Vista section, the kindergarten through the third grade school would welcome 294 students. With enrollment on the rise, a large addition was completed in 1972. Following Connor's death in 1984, the school was renamed R. P. Connor Elementary School.

Gathered around the table are 11 "boys" and their former teacher. In August 1934, the group held a reunion in the Eureka House to "talk about the good old days 50 years ago." Their teacher, by then police judge Frank "Pop" Wiley, brought to the dinner the ruler he sometimes used on their knuckles many years before.

SACRED HEART PAROCHIAL SCHOOL

In November 1910, the new Sacred Heart School opened to 70 pupils. It was built on Lafayette Avenue, adjacent to the rectory, and designed by Nyack architect F. X. Rousseau. The gilded cross on the facade was taken from the old frame church. There were four classrooms on the first floor and a large open gallery on the second floor. Four more classrooms were added in June 1939.

The ground breaking for the new Sacred Heart School and Convent was held in December 1959. At the controls of the steam shovel is Msgr. James P. Kelly. With him are architect Robert Green (left), Suffern mayor James P. Rice (in the light jacket), and Fr. Thomas Gallagher. The new school on Washington Avenue featured 16 classrooms for 555 students, ranging from the first through the eighth grade, and a gymnasium-auditorium. They moved into the school on March 13, 1961. (Suffern Village Museum.)

Eight

MAKE WAY FOR THE THRUWAY

In the fall of 1945, word came from Albany that a decision had been made to construct a great superhighway, called the "thruway." Gov. Thomas E. Dewey had urged the legislature to authorize the department of public works to establish the route for a $202-million six-lane express highway. It was heralded as the "most important single engineering project" in the state since digging the Erie Canal, more than a century before.

The thruway was to span the state from Buffalo to Albany and south to the New Jersey border, terminating at Suffern. The village would serve as the gateway to "New York's Main Street." When the project was proposed, it was welcomed by Suffern and neighboring villages located at the mouth of the Ramapo Pass. For years, their streets had been chocked with traffic seeking a path to upstate New York. Traffic had become unbearable, especially on weekends.

In the years that followed, the massive plan underwent several redesigns. The engineers directed that the highway not end at Suffern, but turn east to cross the county to Nyack, where it would cross the Hudson River. The cross-county alignment would take several detours before being finalized.

The plan for carving its way through Suffern, adopted after fierce opposition, was to have the superhighway cross Lake Antrim, shifting the road from an earlier path and skirting the state line in the West Ward. The new path would save 60 homes and protect Suffern's well fields. It would, however, ruin the scenic recreation area at Lake Antrim, the site of Suffern's bathing beach and memorial park. To engineers, it was ideal, more direct, and a better alignment.

What the Erie Railroad had done to awaken a rural, sleepy community of the 1850s, the New York State Thruway, almost a century later, would do again on a greater scale. In order to make way for the thruway, Suffern would be left with an indelible mark, forever changing its landscape and way of life.

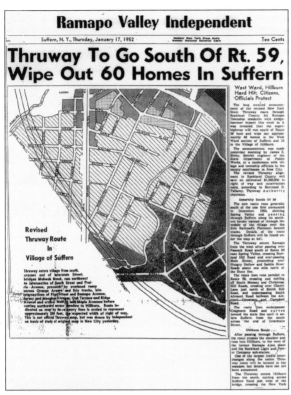

Ramapo Valley Independent

Suffern, N. Y., Thursday, January 17, 1952 Member New York Press Ass'n / Member National Editorial Ass'n Ten Cents

Thruway To Go South Of Rt. 59, Wipe Out 60 Homes In Suffern

West Ward, Hillburn Hard Hit; Citizens, Officials Protest

Revised
Thruway Route
In
Village of Suffern

The word was out. The bold headlines of the *Ramapo Valley Independent* in 1952 gave Suffern the grim news. The construction of the thruway would have a disastrous effect on the village. Through Suffern and the Ramapo Pass was the first option for the superhighway's path. Fortunately for residents of the West Ward, the realignment would spare that part of the village.

Construction of the thruway in Suffern would not be without controversy. On November 5, 1953, the *New York Times* carried a story and photograph of the three Suffern police officers guarding the village water supply in response to the thruway attempting test borings at the well fields. City tabloids embellished the story, creating tales of police threats of gunplay.

With construction in full swing in the fall of 1953, this view that is looking west from Oak Lane (today Pavilion Road) shows the start of heavy machinery cutting through the rocky slope. Blasting would follow. The Peterson home at 76 Wayne Avenue is the large house to the left and was slated to be moved up the hill.

In October 1953, Wayne Avenue resident John Wanamaker took this image entitled "A Picture of Loneliness," showing the last remaining vestige of Oak Lane, a road constructed in 1886 by George W. Suffern. It scaled the mountain just west of Washington Avenue. In 1897, a pavilion, which later burned, was built at the top. When the thruway rerouted the road, the name was changed to reflect its history.

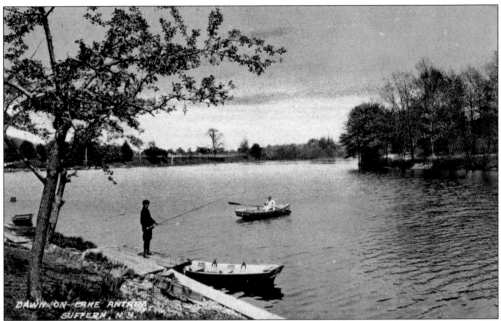

In 1869, the Mahwah River was dammed, flooding 26 acres to create Lake Antrim, which was used for a time as a source of drinking water. A scenic drive was constructed around the lake, a popular place for fishing, boating, picnics, and social gatherings. The picturesque setting surrounding this "beautiful sheet of water" was a source of great pride for residents.

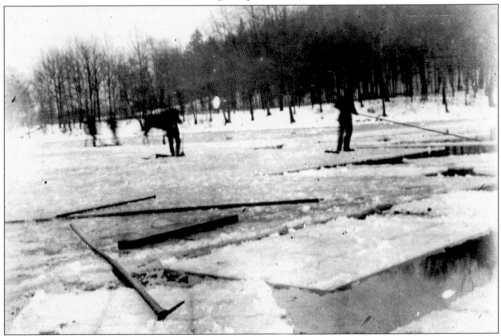

This photograph shows men cutting ice on Lake Antrim. Once the ice was thick enough, a horse would be brought out to haul the blocks of ice as they were cut. Two large icehouses were built on the north shores of the lake, which later became the site of the thruway bridge. The ice blocks would be stored there, kept cool with sawdust, before being delivered to homes and businesses.

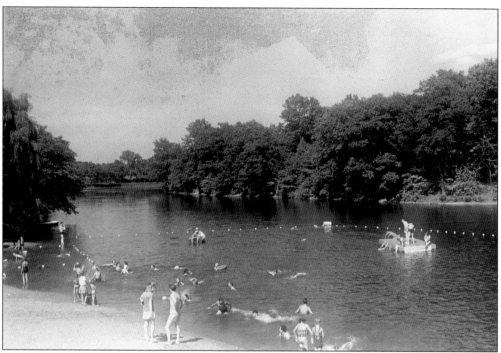

In January 1933, the village paid $15,000 for the corner lot on the banks of Lake Antrim, at Washington and Wayne Avenues. Suffern established its first park, creating a beach and recreation area. Sand was trucked in, a dock was built, and a village lifeguard was assigned during the swimming season. A playground was installed, and recreation programs were offered to village children. Trees were planted in the park, including some with stone tablets bearing names of residents killed in World War I. It was a popular haven during summer months. That changed in July 1953, when thruway crews began cutting down the trees in the park. The swimming area was obliterated with huge piles of stone that were used in preparation for the bridge, which would span a much narrower opening.

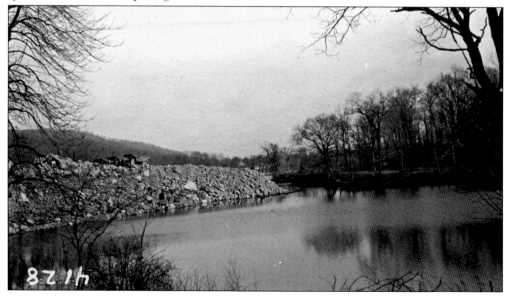

This winter scene was taken in early 1953 prior to the start of thruway construction. It shows the handsome stonewall in front of the homes of Mildred Winfield and Elizabeth M. Clark, on the north side of Wayne Avenue (70 and 72 Wayne Avenue). The two houses were among five on the mountainside that were in the direct path of the thruway.

The Casa Lago, which was considered Suffern's first apartment house, was built in 1930 at 93 Wayne Avenue. In 1953, it was owned by Bill Oster and fell victim to the wrecking ball for the thruway. Four buildings on the south side of the road would be impacted. The home of Esther Grinton, pictured to the left, was moved in September 1953 to 188 Wayne Avenue.

Thruway workers ponder how to remove a 4-ton boulder from the kitchen of Charles Tedesco's home at 14 Wayne Avenue. On March 18, 1954, the rock tumbled down the mountain after being jarred loose by nearby blasting operations. Fortunately, no one was hurt. Charles's wife, Frances, had left the kitchen minutes before the blast.

On September 2, 1953, the Clark home, formerly of 72 Wayne Avenue, rests for the night in front of the Wanamaker home at 120 Wayne Avenue. In the path of the thruway bridge, Minnie Stephenson purchased the home. A local newspaper noted, "The house moved at a rapid rate for a house," when it was relocated to a vacant lot near 147 Wayne Avenue.

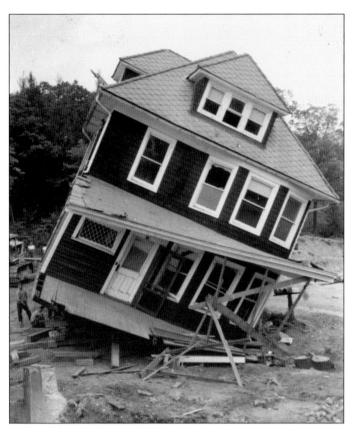

The Peterson home at 76 Wayne Avenue was directly in the path of the thruway. The Knights of Columbus purchased it for $1 to use as a clubhouse and hired a contractor to move it up the hill to a new site on Oak Lane. During the move on September 20, 1953, an axle broke on the trailer, the weight shifted, and the house toppled over. The interior photograph below details how badly the home was damaged. As they continued up the hill, repeated efforts were made to stabilize the structure with new rigging. The grade was apparently too steep and the walls buckled, causing the house to collapse. After having tried for more than a month, it was determined that the structure could not be salvaged.

This September 1954 photograph shows daylight through the steel work from the underside of the thruway bridge over Wayne Avenue. Construction of the bridge at Lake Antrim had also begun. The original design called for an ornamental stone bridge spanning the lake, but engineers deemed that too costly. Massive amounts of rock were trucked in, reducing the size of the lake and creating a narrow channel under the thruway bridge.

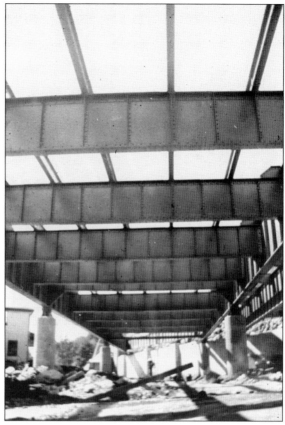

In August 1953, another Suffern landmark was forced to make way for the thruway. The *New York Times* noted that the Eureka House, "the last of Rockland County's historic roadsides inns," was forced to close and yield to the highway. The photograph shows the once popular restaurant and bar—a community meeting place since 1869—with its windows removed prior to demolition in the spring 1954.

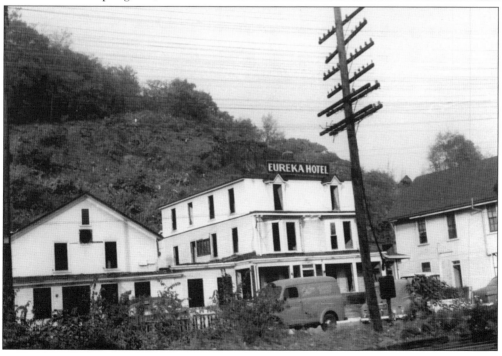

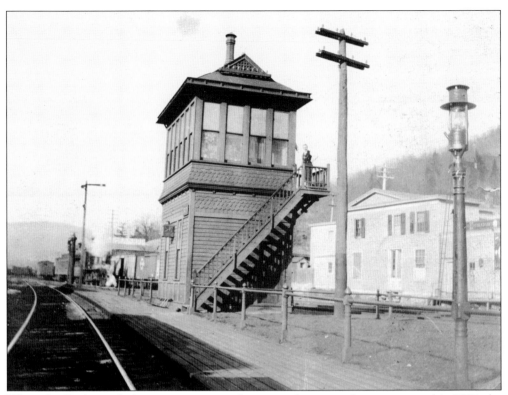

When the Erie's interlocking tower, seen in the image above, was first constructed in 1898, the two-story wood-framed building stood tall in the rail yard, giving the operator an unrestricted view as he used 36 levers to activate track switches in the busy yard. Years later, a super highway would dwarf the tower. The photograph below shows the 1954 construction of the abutments and steelwork for the bridge that would carry the thruway over the railroad and Orange Avenue. During this project, the subsoil under the tower was compromised, and the building began to lean. Huge timbers were needed to keep it from toppling over. Nicknamed the "Leaning Tower of Suffern," it remained a unique landmark until the spring of 1987, when it was razed. (Both, Suffern Village Museum.)

Trooper Thomas Sackel stands next to his car in front of the impressive New York State Police barracks in Suffern. Located on the side of Union Hill, the former Martin estate, just off Hemion Road, was taken over by state police in October 1954. With an eight-man detail, the troopers were responsible for patrolling 28 miles of highway, from the Tappan Zee Bridge to Harriman.

The thruway opened in 1955 and change was on the horizon. Inspired by a vision in 1962, planners urged, "With urban renewal, central Suffern could look like this." The design was to redevelop 20.7 acres in the lower business district into a modern shopping center, an industrial park with office buildings, and a 30-unit public housing project. Suffern residents did not share their vision and voted it down, 694-375.

www.arcadiapublishing.com

Discover books about the town where you grew up, the cities where your friends and families live, the town where your parents met, or even that retirement spot you've been dreaming about. Our Web site provides history lovers with exclusive deals, advanced notification about new titles, e-mail alerts of author events, and much more.

Find Your Place in History.